Nina Kränsel

D0764651

Gustav Klimt

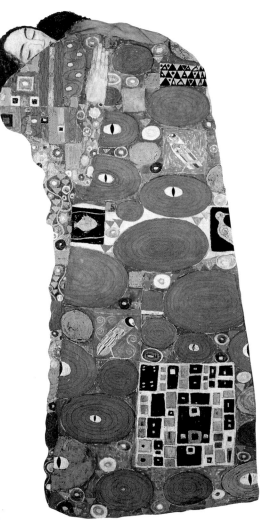

Prestel
Munich · Berlin · London · New York

Context

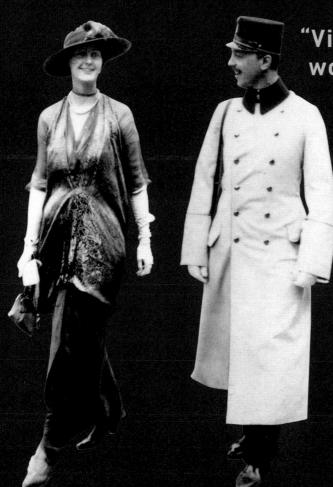

"Vienna – that wonderful, inexhaustibly magical city, with its mysterious, light-saturated air!"

Hugo von Hofmannsthal

Viennese Modernism ...

... was born of the *fin-de-siècle*. In a mere two decades – the 1890s and the 1900s – Vienna produced superb achievements in art, literature, music, and ideas. What would the world be today without Freud's psychoanalysis, Mahler's symphonies, Schoenberg's twelve-tone music – or Gustav Klimt's pictures?

Morbid metropolis

Around the turn of the 20th century, a feeling of doom spread through Vienna – morbidity and a pervasive death-wish became characteristic of Viennese culture. Life and death, ugliness and beauty – nowhere were these as fascinating to artists and writers as there, in the city on the Danube. And it was precisely this special atmosphere that brought about a unique concentration of creativity and genius. In Klimt's day, all the familiar bastions were under siege, including liberalism, masculinity, and Jewish identity. Struggles for emancipation were undermining a male-dominated world. The ever-growing anti-Semitism of the German nationalists and Christian Socialists was eating away at the internationalism of Vienna, which was then the capital of the Austro-Hungarian Empire. Viennese Modernism – which lasted until the end of World War II – provoked violent opposition from conservative factions.

Viennese society: detail of a poster for a cabaret called *Die Fledermaus*, 1908.

In 1900 ...

-→ Vienna played a major role in the life of Adolf Hitler. In 1907 and again in 1908, the Academy of Art turned him down as a student. Later, he would label the modern art being produced in Vienna as 'degenerate,' first banning and then destroying it.

-→ The Austro-Hungarian Monarchy was on its last legs. Towards the end of the 19th century, the right to vote (until then a privilege reserved for the few) was greatly extended.

Fashion and morality

"You need only look at fashion, for the fashions of any century instinctively reveal its morals in the way it expresses its tastes visually." Stefan Zweig

The son of a rich Viennese industrialist family of Jewish origin, the writer Stefan Zweig (1881–1942) spent much of his life in Vienna. He experienced a time of radical change in fashion during which women in particular were obliged to change their wardrobe regularly in order to keep up with the times. Whereas in the late 19th century the strict dress code for women required lace-up bodices, stiff corsets, and hoop skirts (with women often fainting because they could not breathe properly), fashion changed completely in the flowering of creativity between 1890 and 1910. Progressive society ladies began to wear modern styles such as those designed and made

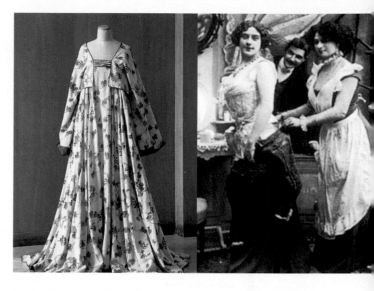

in the fashion salon of Klimt's intimate friend, Emilie Flöge. These new garments, which flowed softly and expansively round the body, occur time and again in Klimt's own paintings.

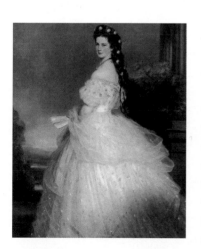

Fascinating Sissi

Known as Liesl of Possenhofen, or simply as Zopfliesl (Lisa Pigtails), the girl who later became the Empress of Austria and Queen of Hungary represented the spirit of the *fin de siècle* in Vienna more than anyone else. Born in Munich on 24 December 1837 as Elisabeth Amalie Eugenie, daughter of the Duke of Bavaria, in 1854 she married the Emperor Franz Joseph. Now widely known as Sissi, she is a figure who continues to fascinate the public, not least thanks to several popular films. In her sensitivity, excitability, restlessness, homelessness and egocentricity, she took the cult of the individual so typical of the period around 1900 to extremes – and suffered for it. She very deliberately cultivated the legend of the beautiful, misunderstood, and lonely figure who refused to be seen as just an empress. And she paid the price. Visiting Geneva in 1898, Sissi was stabbed to death by an anarchist.

Fin de siècle

… means 'end of the century.' It refers to the period between 1890 and 1914, two and a half decades of extraordinary creativity and extravagant lifestyles, both of which frequently tipped over into decadence. The *fin de siècle* was feared as the time leading up to an apocalypse, an inevitable period of decline after the glories of the Belle Époque. The term itself was borrowed from a play of that name written by the writers Francis de Jouvenot and H. Micard, and has now come to refer to the heightened sensibilities of the period before World War I.

The cultural heart of Vienna *c.* 1890. In the foreground the new Burgtheater, with the Old Town behind it.

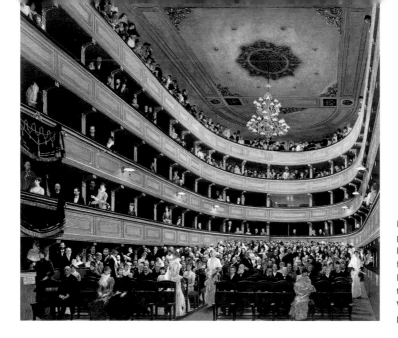

Literally a society portrait: Klimt painted this picture in 1888 when he was commissioned to record for posterity the interior of the old Burgtheater, which faced demolition. It depicts notable figures of Viennese high society with almost photographic precision.

Vienna

Europe was changing fast – but going where? In the decades around the turn of the century, a vibrant Vienna was the stage where numerous brilliant personalities played colorful parts – looking for answers, looking for themselves. Gustav Klimt was one of them, and his answers are in his works.

City of contrasts

In hindsight, you might think that the period leading up to the 20th century was one of confidence and blithe optimism. Far from it. The turn of the century was not a time of cloudless confidence in a bright and untroubled future. The intellectual and cultural climate in fact pitched rapidly between highs and lows. Existence was strongly colored by a simultaneous belief in progress and a feeling of doom. People were fascinated by the possibilities of technology and the latest successes of industrialization, but at the same time keenly aware that the limits of progress were beginning to appear. Rapid urbanization brought new problems. Migrants streamed into the metropolis of Vienna from all parts of the Austro-Hungarian Empire. They all

> **"The Theory of Sexuality is our mythology. Sexual urges are mythical creatures, grand in their uncertainty."**
>
> **Sigmund Freud**

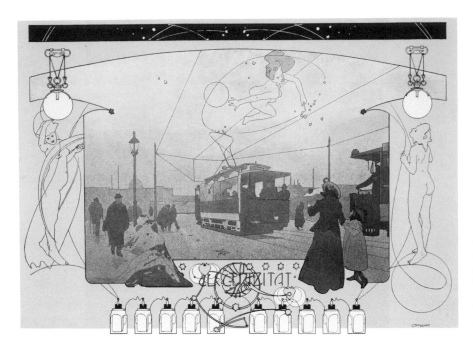

In Vienna at the turn of the century, art was often allegorical, with artists seizing the opportunity to treat fashionable subjects in science and technology. This picture is about electricity.

needed a safe water supply, as the higher population density greatly increased the risk of epidemics. The construction of the very first Viennese supply of mountain-spring water in 1870–1873 was a milestone in the new urban infrastructure. Society would have to face a range of practical challenges.

From stability to instability

Many in society were still cocooned in a smug feeling of security, however. After all, peace had reigned since the 1860s. There seemed to be no serious threat to body and soul, and the relative security and general prosperity enabled people to look forward to the future without anxiety. But behind the façade, crises and tensions were building up. There was trouble brewing between rival nationalities, and deep discontent at social inequalities suffered by the lower classes troubled the political establishment. As it neared its end, the brilliant culture that had flourished during the Belle Époque was now afflicted by increasing anxieties.

A period of deep unrest, it generated a whole series of important thinkers, musicians, writers, and artists. The intellectual climate was greatly influenced by Sigmund Freud (1856–1939), who founded psychoanalysis, and in turn influenced men like Ludwig Wittgenstein (1889–1951), one of the leading philosophers of the 20th century. In the theater, doctor and playwright Arthur Schnitzler (1862–1932) portrayed Viennese society in all its elegant decadence. Gustav Mahler (1860–1911) was the inspired composer whose works spanned the transition from late Romanticism to Modernism, while Arnold Schoenberg (1874–1951), venturing into uncharted territories, developed his revolutionary twelve-tone music. Two of the major artists inspired by this period were Egon Schiele and Oskar Kokoschka, both of whom had the same teacher – Gustav Klimt. His candid exploration of the human psyche prepared the way for German Expressionism. Viennese Modernism was closely bound up with the brilliance of Klimt's pictures, achievements in

Brilliant essayist and critic Hermann Bahr, who was a close friend and supporter of Gustav Klimt.

Playwright Arthur Schnitzler, whose plays fascinated Viennese society.

literature, and new developments in music – though of course none of these cultural highlights helped to solve the deep malaise afflicting society – even though the Secessionist thought art could and would. Anti-Semitism increased, and the different peoples of the empire became embroiled in bitter nationalistic disputes. Despite – or perhaps because of – the contrasts between the progressive and the backward looking, between liberal and conservative, it was a favorable climate for creativity, a highly charged atmosphere that made the period extraordinary.

The dream of harmony

The underlying disunity of the era gave rise to a longing, in fact a need, for harmony and for the removal of conflicts. Artists sought the key to 'total art' – to works of art that would successfully combine art, science, art, and metaphysics. Inspired by the composer Wagner (1844–1883) and by the philosopher Nietzsche (1844–1900), the Austrian critic and playwright Hermann Bahr (1863–1934),

Klimt, and like-minded artists of the Secession, sought a 'path to the total work of art.'

Freud's treatises on sexuality were profoundly influential. Klimt also used sexuality and eroticism as subject matter in countless sketches, drawings, and paintings – even in his portraits of the leading women of Vienna's high society there is a subtle but pervasive aura of sex. But besides his principal subject matter (women), he also painted restful landscapes and elaborate allegories. He grew up in the most productive years of Viennese historicism (art based on the styles of the past), and in a world full of symbols, and these two influenced are clearly seen in his work. However, Klimt abandoned the traditional approach to his themes in favor of one that introduced contemporary elements, moods and feelings into his works. The ethereal Symbolism then practiced in Belgium, Holland and France as a response to Realism was of no interest to Klimt and Viennese society. The Viennese were too attached to real flesh and earthly love, to life and death in the here and now.

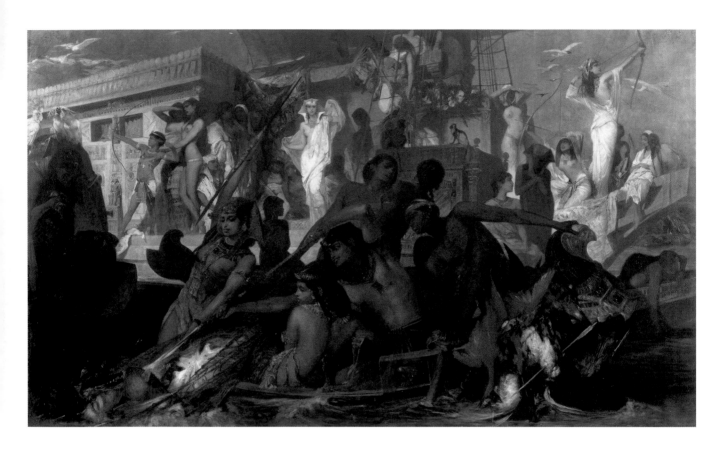

The prince of painters In the late 19th century, Hans Makart was one of the most sought-after Viennese artists, and his opulent history paintings deeply impressed the young Gustav Klimt. Makart painted the *Nile Hunt* following a visit to Egypt. The exoticism of oriental scenes had a great appeal at the time.

An early work In his early days, Klimt conformed closely with the prevailing taste, which was best represented by Hans Makart (opposite page). This female nude, *Fable*, which Klimt painted when he was twenty-one, is closer in style to the nudes of the Italian Renaissance than to the *femmes fatales* that would populate his later pictures.

Fame

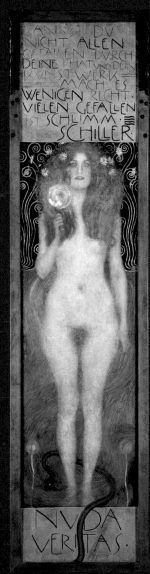

"If you can't please everyone with your deeds and art, please just a few. There is no virtue in pleasing the crowd."

Friedrich Schiller,
as inscribed on Klimt's
painting *Nuda Veritas*

Ahead of his time …

… Klimt was praised by some, but condemned and ridiculed by many. His works deeply disturbed Viennese society. The unconcealed sexuality of his paintings affronted conservative morality, and the originality of his style and of his treatment of traditional subjects alienated critics and public alike. Yet he was the leading Austrian artist of the *fin de siècle* and a major influence on subsequent generations.

A fickle public

Klimt's standing with the Viennese public, the imperial court, and the Austrian state changed frequently. In his youth, he and Franz Matsch were commissioned to produce designs for the ceiling of the Aula Magna, the University of Vienna's assembly hall. However, there was wide condemnation of the 'faculty pictures' (as they were known) as ugly and pornographic, and eighty-seven professors signed a petition opposing the admission of his depiction of *Philosophy* to the hall. Klimt withdrew his works and turned his back on the public. Ironically, *Philosophy* won the gold medal at the World Fair in Paris. And although his name was put forward three times, Klimt was never appointed to a professorship at the Vienna Academy of Art – once, even the Emperor, Franz Joseph, intervened to prevent it. However, in 1917 he was at least made an honorary member of the academies of art in Munich and Vienna.

Detail from *Philosophy*,
a work too daring for Vienna.

→ Klimt revered history portrait painter Hans Makart (1840–1884), who exercised a great influence on him.

→ The French sculptor Rodin (1840–1917) admired Klimt. At the Beethoven exhibition of 1902, Rodin had eyes only for the *Beethoven Frieze* by Klimt.

→ Klimt and Schiele greatly respected each other. It was Klimt who discovered and promoted Schiele.

Special edition!

Austria's leading art journal at the turn of the century, *Ver Sacrum* (Latin: 'sacred Spring') was published by members of the Secession. In form and content it was a publication of the highest quality, with great attention paid to the design, which was handled mainly by Klimt, Koloman Moser, and Josef Hoffmann. From 1898 to 1903, this journal was where the leading writers and poets at home and abroad were published, including Rilke, Hermann Bahr, and Hugo von Hofmannsthal.

The 'Golden Apple' ...

...was what the Viennese called the Secession Building in Friedrichstrasse. This new building, designed by Secession architect Joseph Maria Olbrich, was completed in 1898, when it was immediately used to exhibit works by the Secessionists. The nickname was given to it on account of its ornamental golden cupola. Today, it contains Klimt's *Beethoven Frieze*, though the public had to wait until 1986 to see it again as it had been removed many years before.

Against ugliness ...

...and at all times for beauty. The period between 1890 and 1914 was the heyday of Art Nouveau, called *Jugendstil* in Germany after the illustrated art periodical *Die Jugend*, first published in Munich in 1896. Art Nouveau was a conscious revolt by artists. First, they wanted to unite the fine arts with the crafts and so make all forms of creativity equally important. Industrialization had destroyed the uniqueness of the arts and crafts – mass production was the cause. Art Nouveau artists were also looking for a new artistic identity, and they were keen to reject styles based on the past. It was a wish that a great number of artists, designers and craftsmen shared – the movement flourished right across Europe and in the United States. Drawing on sinuous plant forms, Art Nouveau artists created elegant, shadowless figures that often seem to float above the ground, etherealized figures often linked to mysticism. Art Nouveau prepared the way modern art.

Secession

At the end of the 19th century, tensions developed between progressive and the conservative members of the leading artists' society in Vienna, the Wiener Künstlerhaus. Klimt and a number of other artists founded their own breakaway association, calling it the Secession. Their aim was to 'strive for truth' and to create 'total works of art' combining architecture, painting, the crafts, and sculpture.

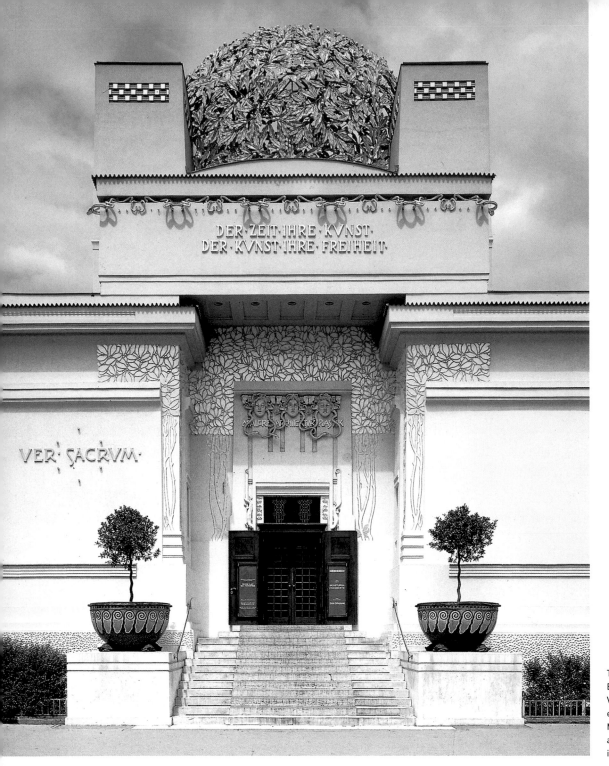

The Secession
Building in
Vienna, design-
ed by Joseph
Maria Olbricht
and completed
in 1898.

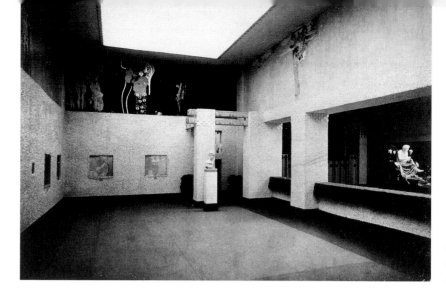

View of the room at the Vienna Secession Building showing Klimt's *Beethoven Frieze*, c. 1902.

For the time, its Art – For Art, its freedom.

Co-founder, chairman and chief representative of the Viennese Secession, popular society portraitist, influential figure in art and cultural affairs – Klimt's list of achievements during his early career was a long one. But he was also the main target of his contemporaries' bitter criticism.

Artistic freedom

The turn of the century was a time of change, and Klimt was emphatically involved in shaping his era. Full of bright colors and striking figures, his works broke with the taste and even the morality of the time, fascinating and offending the public in equal measure. This response of attraction and aversion was something Klimt often experienced, partly because his own objectives were constantly changing. Artistic freedom was his watchword, and he would not compromise.

> "I'm quite resilient to attacks in general. But the moment I feel that my client is not satisfied with my work, I get very touchy indeed."
>
> **Gustav Klimt**

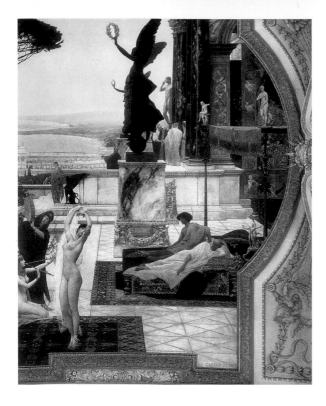

A commission for the Künstler Compagnie: the stairwell of the Burgtheater in Vienna, with paintings by Gustav and Ernest Klimt and Franz Matsch. This scene represents the ancient theater in Taormina.

His early career

Klimt's family background exercised a strong if subtle influence on his work. His father Ernst was an engraver. Klimt himself gained a comprehensive training at the School of Arts and Crafts in Vienna. There, he, his brother Ernst, and Franz Matsch, who soon became a good friend to both of them, studied a wide range of techniques, ranging from mosaics to oil painting and fresco. The brothers and Franz Matsch dovetailed their work very well. They were able to match their styles to such good effect that they could paint as a trio – and the viewer would think the work had been painted by a single hand. It was a combination that was soon in demand for major contracts for large-scale wall paintings.

They gained their first commissions for decorative works in 1880: they designed the four allegories at the Palais Sturany in Vienna, and also the ceiling painting in the spa rooms in Karlsbad. Klimt's great inspiration at the time was Hans Makart, the most respected Austrian artist of the day, known for his history subjects, painted in an elegant Baroque style. When Makart died prematurely at the age of forty-four, leaving an important commission unfinished – the staircase in the Kunsthistorisches Museum in Vienna – the Künstler Compagnie (which is what the three artists called themselves) were contracted to complete the job. It was a real and welcome challenge for the young and ambitious Klimt.

A style of his own

For several years the trio encountered nothing but success, praise and admiration. In short, Gustav, Ernst and Franz seemed to be on the threshold of successful careers as artists serving the monarchy. But fate had other things in store for them. In 1892 Ernst died, and soon afterwards the Matsch-Klimt partnership broke up. Klimt felt an increasing desire to go his own way: he was no longer content to be indistinguishable from his friend and colleague Franz Matsch. And soon his own works acquired a distinctive style, notably as he began to depict the figures in his paintings (especially the women) in a new way. His approach was nothing short of scandalous,

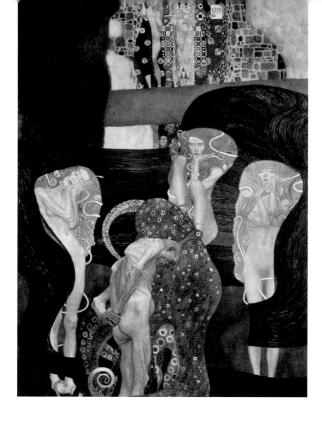

In the 'faculty picture' *Jurisprudence*, instead of the victory of justice, Klimt depicts a state of hostility and doubt. The three faculty pictures were destroyed by fire during World War II.

The Girl from Tanagra was intended as an image of Greek Antiquity, but Klimt depicts a women very much of his own day. Many contemporaries were reminded of the women on the morally doubtful edges of Viennese society.

for up to then portrait painters had tended to idealize their sitters. But Klimt wanted to breathe life into his figures, giving them the real features and feelings of people of his own day. Moreover, he often gave the women – their hair loose, their eyes half closed – an unmistakably sexual and seductive character. These and other breaches of social, moral and artistic etiquette brought a swift response from angry critics.

Controversy

Although Klimt and Matsch had dissolved their Künstler Compagnie partnership, they were nonetheless jointly commissioned to design pictures for the new university building intended to accommodate the faculties of Medicine, Philosophy, and Law. And for these Klimt designed the allegories *Medicine*, *Philosophy*, and *Jurisprudence*. But they triggered off a storm of indignation. Professors, critics, and even members of Parliament lodged strong objections. Klimt, still a young artist, had dared to challenge the establishment. Society was shocked to find him rejecting the stated wishes and

advice of their leading academics. He painted nude pregnant women! He showed mankind wandering helplessly in chaos, and painted death and transitoriness in pictures that were supposed to praise the achievements of medicine. The very public controversy around this commission hit Klimt hard. It was not much consolation that *Philosophy*, scorned at home, won appreciation abroad when the painting was shown at the Paris World Fair in 1900, gaining the top prize. In his own homeland, Klimt felt completely misunderstood, and in the end refused to hand the pictures over to the university. He repaid the fee he had already received and found other patrons to take the

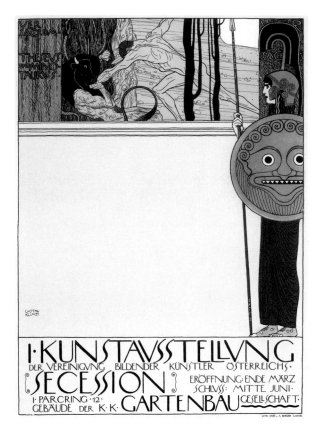

Hermann Bahr wrote ecstatically of the first Secession exhibition that it was "An exhibition in which there are no bad pictures." However, Klimt's poster came in for official censorship because it showed Theseus and the Minotaur fighting – both of them naked. A second version had to be produced with a tree covering the offending nudity.

pictures. His early confidence in public opinion and in the state as a client was shaken to the core.

A new direction

Rumblings were heard in artistic circles in Vienna. Klimt was a member of the artists' association, the Künstlerhaus, in Vienna. However, unable to go along with the 'old gang' any longer, Klimt and a group of other dissatisfied members left the association – the generation gap could no longer be bridged. And so Klimt and the architects and designers Josef Hoffmann, Otto Wagner and Joseph Maria Olbrich – there were altogether twenty 'Secessionists' in all – set up an association of their own. And that is how the Viennese Secession was born. The *junge Wilden*, with Klimt as their chairman, were aiming high. They wanted the censors to treat them as adults, not children, they wanted to seek the truth, however challenging it was,

and they wanted to paint not only what they saw but also what they felt. The Secessionist also set themselves the task of championing the arts and crafts, which, they argued, were treated as second-class – all the art and the various crafts should have equal status. The group wanted to 'unite art for the rich and art for the poor,' and to express sensuality more freely. The Secessionists also wanted to create a great *gesamtkunstwerk* (total work of art), with elements from all fields of art. Finally – they wanted their works to change society.

A temple to art

The artists in this new group around Klimt wanted an exhibition venue of their own. And they soon created one: Olbrich designed a 'temple of art' in which the Secessionists could present their works. Soon their new Secession Building with its celebrated golden dome was ready, a place where, from 1898, avant-garde Austrian artists could exhibit. Like-minded artists from abroad were invited as well, for the revolutionaries welcomed all new art with open arms. Above the doorway, the

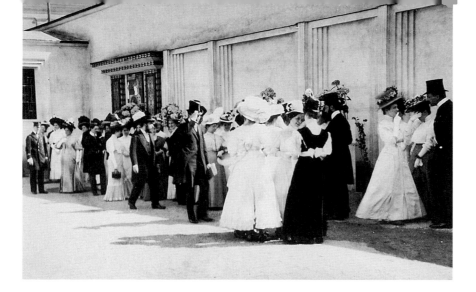

Opening day of the art show. Initially, Klimt's work was a magnet for the public. When the *Beethoven Frieze* controversy broke, however, the number of visitors soon fell.

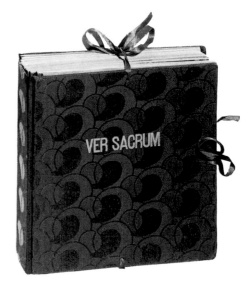

movement's motto, thought up by the art critic Ludwig Hevesi, was proclaimed in letters of gold: "For the time, its Art – For Art, its freedom." The Secessionists also published a publication of their own, *Ver Sacrum*, which Klimt worked on for two years.

Art periodical *Ver Sacrum*, organ of the Vienna Secession. This is the first year's issues, bound in a cloth binding designed by Secessionist artists.

Beethoven Frieze

One of the most notable events in the history of the Secession was their 14th exhibition in 1902. The whole show was devoted to the genius of Beethoven, and the focal point was a large sculpture of the composer by Max Klinger. The event posed a novel challenge to the group – to create a total work of art, a *gesamtkunstwerk*. Josef Hoffmann took on the design of the interior of the Secession Building, and Mahler was responsible for the musical side, a performance of Beethoven's Ninth Symphony – everything revolved around the composer and the statue dedicated to him, who became an ideal for the Secession: the creative genius who devotes himself wholly to the power of art. Klimt created another milestone in his work for the occasion – the *Beethoven Frieze*, which was painted directly on the wall in the main room, in three large sections. Visitors were shocked by the frieze, which they found crude, immoral and totally lacking in respect. Images of ugly women – particularly the allegories of *Unchastity*, *Voluptuousness*, and *Excess* – dismayed viewers, who were looking for images expressing moral elevation and the glory of the divine spark. Klimt's own intentions were in fact no different. The *Beethoven Frieze* is invested with all his understanding of and insight into Beethoven and the meaning of life, the culmination being *This Kiss for the*

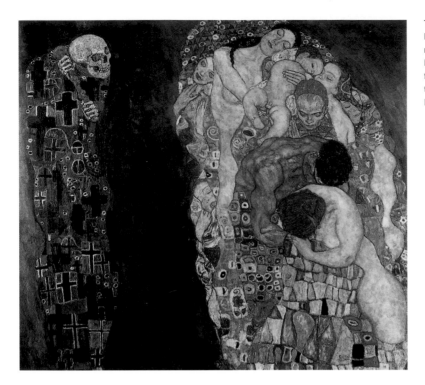

This picture, *Death and Life*, won Klimt the first prize at an international exhibition of art in Rome. Many people assume that the soft face of the mother (top center) is that of Klimt's life-long partner, Emilie Flöge.

Whole World, a title taken from Schiller's *Ode to Joy*, which is used in Beethoven's Ninth Symphony. His prudish contemporaries could find no inspiration in it, however, and stayed away. The exhibition was a financial disaster.

Failure at home

As Klimt transgressed the limits of 'good taste' again and again with his depictions of the naked body and his fascination with sexuality, the public withdrew its favor – and withheld commissions. Even within the Secession, Klimt lost ground – the sad failure of the Beethoven exhibition went far too deep. So in 1905 he left the Secession. What had been a sparklingly creative group of Secessionists fell apart, until finally even *Ver Sacrum* was abandoned. Klimt withdrew completely into his private life, working hard in his studio in Vienna and spending the summer holidays in the country. He was financially independent as he had a few rich patrons whom he supplied with striking portraits. With these, he put great emphasis on keeping his clients happy. When it was left to him what to paint, he became increasingly absorbed in his depictions of women. *Femmes fatales* dominated his work more than ever, but themes of death and transitoriness were also frequent subjects. He now embarked on his 'Gold Period,' producing mosaic-like pictures and portraits that gleam with gold. His *The Kiss* and *Portrait of Adele Bloch-Bauer* are the two great masterpieces of this phase (pages 41 and 42).

Success abroad

In an art show that Klimt organized with artists who had left the Secession, he was finally accorded fervent public admiration. The show became a real celebration of Klimt, with sixteen of his works being shown.

The following year, a similar show was put on, only this time foreign artists were also invited: Van Gogh, Munch, Matisse, Lovis Corinth. By then, Klimt's influence on the next generation was also becoming evident. Egon Schiele and Oskar Kokoschka, whose paths into the exhibition had been smoothed by Klimt, made no bones about who their model was. The gold medal of the 1909 exhibition went to

Klimt treated biblical subjects only twice – *Adam and Eve* is one of his last pictures. As a painter of women, Klimt clearly preferred Eve (in the light) to Adam (behind, in darkness)!

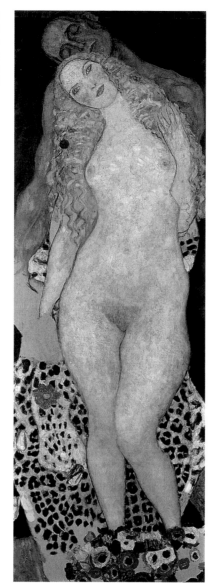

Klimt for his picture of the *Ages of Life* (page 37, right). At an international art exhibition in Rome, Klimt's pictures were greeted with enormous enthusiasm. The admiration of public and press alike followed him to exhibitions in Dresden, Munich, Berlin, Prague, and Venice. In 1911, he was awarded first prize at an international art exhibition in Rome.

Fulfillment

Klimt accepted the homage paid to him at various exhibitions, especially abroad. He was not fond of traveling, however: it was a necessary evil. But it was at least a way of getting to know other artists in their home environments.

What he liked best of all, however, was to be at home in his studio, or to be spending his holidays with Emilie, his lifelong partner, beside the Attersee (a lake in north-west Austria) or in Kammerl near Schörfling. Although he had in effect retired to his studio, he had no objections to amusement – he loved ten-pin bowling, rowing, and the seasonal festivals spent with his patroness Eugenia Primavesi. And he loved women, too. These were his entertainments in the years around World War I, which appears not to have impinged on him much (politics had long ceased to interest him once his vision of art's key role in ordinary life had failed).

In 1916, Klimt, Kokoschka and Schiele took part in the exhibition of the Federation of Austrian Artists at the Berlin Secession. The following year, Klimt was elected an honorary member of the art academies of Vienna and Munich. It was a small consolation for being passed over for professorships all his life as a 'punishment' for his 'scandalous' work. One of the last pictures he was working on before he died was *Adam and Eve*. Like so many of his works, it remained unfinished.

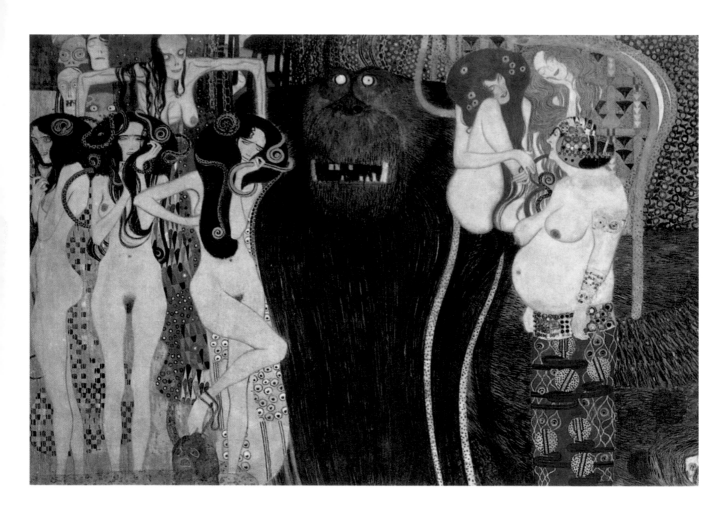

The power of love The *Beethoven Frieze*, one of Klimt's major works, was dedicated to composer Ludwig van Beethoven. It was installed for an exhibition at the Secession Building. It shows the fulfillment of Klimt's utopia – the salvation of mankind through art and love. This section shows the 'hostile powers' that threaten our happiness.

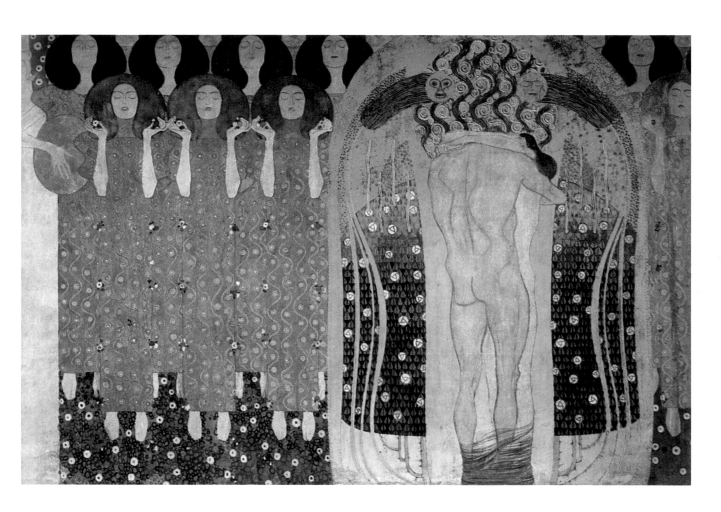

Redemption Whereas the 'faculty pictures' are dominated by forlornness and chaos, the tension is resolved in the *Beethoven Frieze*. The hero, who in the longing for happiness must overcome the dangers of hostile forces (opposite), is redeemed in the embrace of his beloved. The scene represents the line: "This kiss for the whole world," from Schiller's *Ode to Joy*.

Art

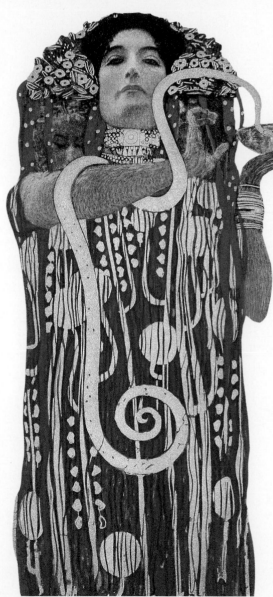

"I'm a painter who paints from morning till night. Figures and landscapes, and more rarely portraits as well."

Gustav Klimt

Elegance and extravagance ...

... are the hallmarks of Klimt's work. His main contributions to the Vienna Secession were his stylized and sensual depictions of women, figures who can appear strangely mysterious to us today. His often dramatic allegories, rich in symbolism, remind us of his preoccupation with the psyche and the search for the meaning of life. His landscapes, by contrast, are wonderfully serene.

Bare facts

Like his one-time inspiration Hans Makart, Klimt liked to depict naked bodies in his pictures. Klimt learnt a lot from Makart, and borrowed compositional features and motifs from him again and again. But Makart's way with nudes was more diplomatic. Known as the 'prince of painters,' who did commissions for the state, he was happy to conform to public notions of decency and morality. He therefore always sought compromises to avoid the disapproval of both the censor and the general public. Klimt, however, would not allow himself to be curbed in this way, and his breaches of social values were provocative. His nudes were often all too frank and sexual for official good taste.

Veiled nudity: a female nude by Hans Makart.

Emperor Franz Joseph I ...

--> **didn't like the paintings of Klimt or the Secessionists. His drivers had instructions not to drive past buildings where Secessionist art was on show.**

Opulent profusion

From the very first, Klimt's style was opulent and highly decorative. Scarcely any of the canvas was left bare. He filled his works with flowers, ornamentation, and geometrical shapes. Even the patterns on the clothes are dizzyingly complex. Klimt also painted and decorated the frames of his pictures. Each patch of empty surface seems to have called for another detail.

Symbolists

The Symbolists were artists who were opposed established styles such as Realism and Naturalism, which were concerned simply to depict things as they appear. Instead, the Symbolists used symbols and allegories as vehicles of expression, and often employed religious and mystical allusions. Themes such as death and eros were the main subject matter of the Symbolists, the main representatives of whom were Arnold Böcklin (left), Ferdinand Hodler, Odilon Redilon, Jan Toorop, and Franz von Stuck.

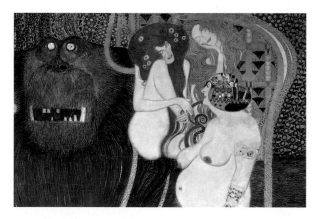

"I want to be rid of it all!"

Public uproar now became almost a stock reaction to Klimt's pictures, and he soon became tired of the constant criticism. In a newspaper interview, he renounced every form of state involvement. "Enough of censorship. I must now take things into my own hands. I want to be rid of it all! I want to get away from all these unproductive stupidities that hold up my work, and to regain my freedom. I don't want any kind of state assistance. The main thing is, I want to make a stand against the way matters of art are dealt with by the Ministry of Education and the Austrian State. Here, every opportunity is taken to undermine real art and real artists. Only the inept and the bogus are favored. Lots of bad things have happened to serious artists that I don't want to discuss here, but one day I shall. I'll take up the cudgels on their behalf. And make things clear for once."

Ornament

Ornament is typically a repeated pattern, often abstract, based on either natural or geometrical forms. Simple or complex, it can be used to decorate a wide range of things, such as fabrics, architecture, pictures, wallpaper, ceilings (stucco), and columns. Ornament has no narrative element and is generally restricted to flat surfaces – though it can be naturalistic and sculptural. Whatever form it takes, ornament is essentially decorative.

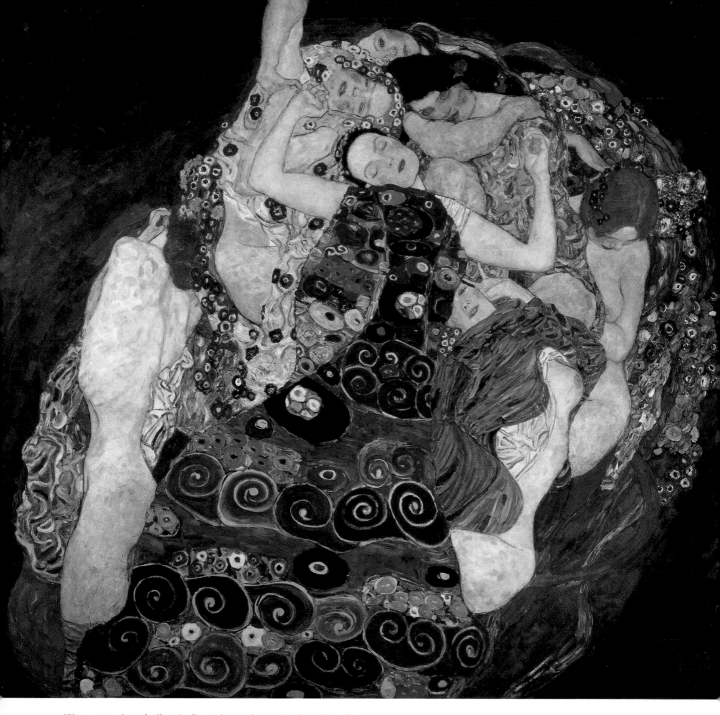

Klimt was perhaps feeling the first twinges of age when he painted *The Virgin* – the young women in this joyful tribute to youth exude a dreamy contentment and lack of concern. Klimt used only pure unmixed colors for the pyramid construction of the composition.

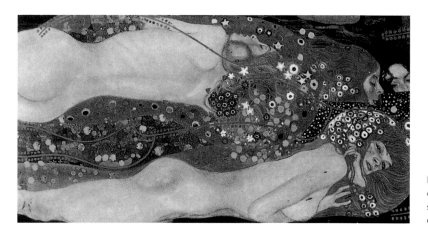

Klimt was a painter of subtle eroticism. Wanton 'water snakes' drift in a world of color and ornamentation.

Intoxicating colors and gleaming gold

Klimt always avoided talking at length about his work. The few things he had to say about his paintings sound modest, almost prosaic. But there is nothing prosaic about the paintings themselves. Time after time they elaborate highly complex themes – Klimt's dramatic allegories are a mirror of his thoughts on life, love, and death.

A rich and varied output

Klimt used his skills as a painter to strive for what he saw as the truth. The four genres into which his works can be divided – allegories, portraits, landscapes, and drawings – are kept together by a force that binds everything: his fascination for life's genesis, growth, flowering, and decay – the cycle of life. He was identified with the Vienna Secession more than any other painter and contributed hugely to the golden aura that invested Art Nouveau in its heyday, handling geometrical stylization, ornamental backgrounds, his preferred asymmetrical compositions, and applications of gold and silver leaf with great virtuosity. Canvas was not his only medium – he also

> "I can draw and paint. That's what I think, and a number of other people say they think the same. But I'm not sure it's true."
>
> **Gustav Klimt**

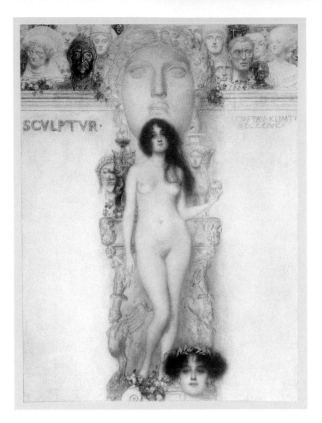

Klimt's *Allegory of Sculpture* of 1896. The figure of Eve holding an apple represents sculpture's power of self-renewal. The two female faces look erotic, alive, and contemporary, while behind them a classical sculpture stares with empty eyes.

decorated rooms with designs that were executed in mosaic. Klimt was a pioneer in the way he linked figures with abstraction. And the rich ornamentation in his works is not purely decorative in character, but also has symbolic intent. His calm, peaceful landscapes stand out for their dense compactness. One can almost breathe the fragrant air rising from the water, meadows and trees. And Klimt's drawings show how the beauty – and indeed the ever-present eroticism – that he saw in women could be captured with just a few strokes.

Living painting

Klimt was in the spotlights of artistic Vienna mainly between 1897 and 1909. He was the one who created an independent style that was in harmony with the development of western European art around the turn of the century without being in the least imitative or eclectic. Klimt's special status, especially in respect of the groundwork he laid for later artists, was mainly due to his ability to introduce his personality into his pictures. His works exude intense personal experience.

Of course, it takes time to develop a personal style. Klimt's first works, which generally relate to historical subjects, still bear witness to a certain academic severity. But Klimt was quick to cast off rules. He soon acquired a distinctive voice of his own, even though at the beginning of his career he was strongly under the influence of Hans Makart. Klimt learnt from Makart what he most admired in him, for example the deliberate use of cursory, sketchy painting. But then he turned towards the wider world, learning from many sources, including Japanese art and the British Pre-Raphaelites. The final step towards establishing his own style came with the death of his brother, which broke up the painting partnership with Franz Matsch. We can trace his development in the first commissioned works for various theaters, the Kunsthistorisches Museum, and the pattern book *Allegories and Emblems*. Particularly while working on the allegories, Klimt allowed himself to give his female figures a contemporary touch. This was new and controversial. The goddesses of mythology and the symbolic pro-

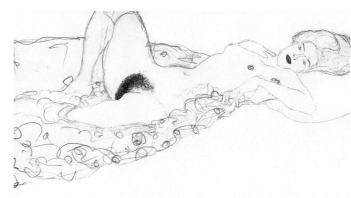

Klimt drew countless erotic sketches of his models, using a striking economy of line to capture the seductive poses the women adopted for him.

tagonists of the allegories are at first glance still couched in a classical idiom, but on a closer inspection they are revealed as Viennese women of his own day.

Klimt breathed life into his figures, managing to convey feelings and moods that are a hallmark of Viennese Symbolism. That is how the concept of the *Beethoven Frieze* or the first *Judith* was created: the works are incontestably symbolical and allegorical, but they are distinct from the Symbolist works found in other parts of Europe, notably France, Holland and Belgium. Symbolism in such countries showed a concern with an otherworldliness that involved a rejection of everyday appearances. Viennese Symbolism, on the other hand, combined the use of symbols with a passion for everyday life, with being rooted in the earth.

Self-realization

Klimt first achieved a style uniquely his own within the framework of the Secession group. He was its leader, but was not one of those who could put his faith in an ideal – such as the sacredness of art – entirely on behalf of a group. So in 1905 he left the Secession, for he was not convinced that the others shared his vision. Moreover, open criticism of his work caused him to retire from the public eye.

He now kept to his studio and began shedding earlier influences. The new century began, and with it, gradually, Klimt evolved a new range of pictorial subjects. The subject matter became more and more private, the approach more subjective, the expression still more personal. The great puzzle of existence continued to fascinate him – sex and procreation, living and dying, the inescapable eternal cycle of life. Men, he believed, were excluded from the mystery of woman,

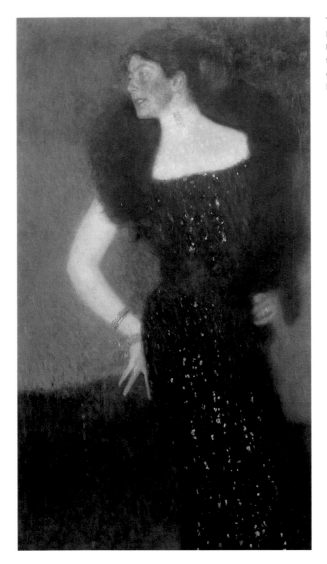

This Klimt portrait shows the aristocrat Rose von Rosthorn-Friedmann, a society lady who was considered strikingly beautiful and very intelligent. Klimt adds an erotic touch by adding a flush of color to her face.

now discovering the skill of letting color speak for itself. There followed allegories such as *Hope*, *The Virgin*, *Death and Life*, and the *Three Ages of Life*. The themes still relate to the dance of life, of course, a fascination that would stay with him till the day he died. But now he treated the theme of the cycle of life in large-format pictures in which color gained in importance, becoming almost as important and meaningful as line.

Seductive women

Except for some very early works, Klimt's portraits were exclusively of women. It is thanks to him that today we associate a very particular type of woman with the time – those who appear to have lived exclusively in Vienna in the late 19th century, and who could live and thrive in that often decadent atmosphere. The elegant eroticism discernible in Klimt's pictures was part of the general mood of the *fin-de-siècle*, but the sexual tension in his works was certainly also a feature of Klimt's own personality. Important here was the influence of Freud's

and yet fascinated by it. Woman represented beauty and power. The aim was to reconcile the two sexes.

This was the vision he painted in what is probably his best-known work, *The Kiss*. Klimt himself called it *The Lovers*, and controversy continues as to whether or not it depicts the love between him and Emilie Flöge.

The intoxication of color

The Kiss was the culmination of Klimt's Gold Period. And then once again he managed to reinvent himself,

The face of this water nymph bears the unmistakable features of Rose von Rosthorn-Friedmann (opposite page), turning an aristocrat into a *femme fatale*. It is not known whether Klimt sought her consent for this image, but the picture remained private for many years.

That women's lives were not just about beauty and sexuality is shown vividly in Klimt's *Three Ages of Life*.

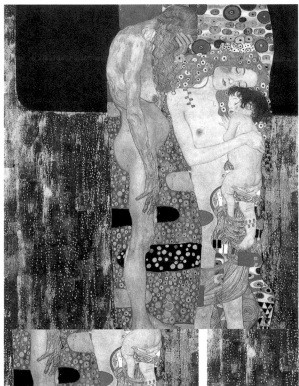

theories on sexuality, which left a deep mark on Viennese life and culture.

Klimt's pictures of women also vary according to the painting technique used, in other words whether gold or color dominated, and whether painted or drawn in chalk. They can also be further subdivided into various phases of 'emancipation.' There are distracted, passive girls who appear unaware of their bodies. Then proud, detached women – cool, self-assured, and yet still magnetically erotic.

Seeing and being seen, and an acute awareness of both – this is what portraiture was all about for Klimt. Whether it involved simple girls or society ladies, there was always a certain tension between Klimt and his models, generally of an erotic nature. But there was also a certain detachment. Klimt was a man who himself fascinated women – but he was also a man they could not see through nor possess. Perhaps that was why they flirted with him so readily.

Art as theater

Klimt approached his portraits according to a set pattern, concentrating his painterly resources on the face and hands, which look almost naturalistic. The rest – clothes, background, and occasionally the frame as well – were covered with a rich fabric of ornamentation.

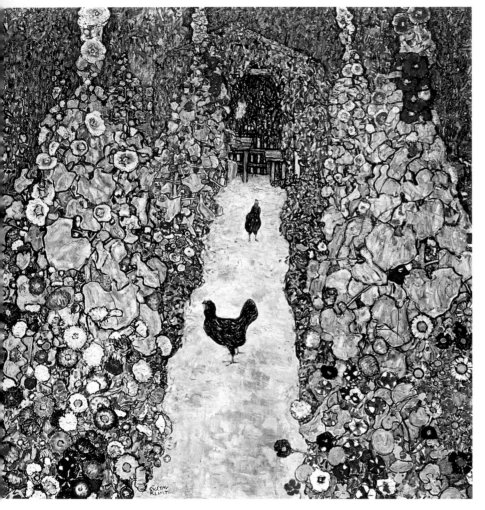

At first glance it looks like a natural wilderness, but in fact Klimt has organized the scene beautifully and with great attention to detail. *Garden Path with Hens* was destroyed by fire at Schloss Immendorf at the end of World War II.

taste with other contemporary artists, notably Van Gogh. The influence of the 'new painting' of his colleagues that gained a foothold not only in France but also in Munich prompted him to work in only two dimensions – but always in harmony with his own style. The backgrounds remained flat, but bodies acquired a more realistic three-dimensionality. Typically, the women stand in foreground of the picture, as on a stage, with cascades of ornamentation falling behind them like a curtain.

Images of nature

The name of Klimt most commonly evokes *The Kiss*, the powerful *Beethoven Frieze*, or his *femmes fatales* – figurative and Symbolist images. It is often overlooked that Klimt was also a superb landscape painter, and that landscapes constitute about a quarter of all his

Klimt liked to use gold for these decorative elements, which increased even more the contrast with the delicate pale skin and (often flushed) cheeks of the women. His first *Portrait of Adele Bloch-Bauer* is one of the best examples of this. The next portrait of Adele Bloch-Bauer, the wife of industrialist Ferdinand Bloch, shows the change from gold to color, mentioned earlier (pages 42 and 43). The autonomous elements in the background were a mark of Japanese influence. Klimt loved and collected Japanese woodcuts, sharing this

A postcard to his sister, Anna. Otherwise a poor correspondent, Klimt often sent 'his women' postcards from his summer holidays, which he whiled away painting landscapes.

works; his first dates from 1898. The landscapes were always painted directly from nature, and so only a few sketches or preparatory studies for the works survive. Whereas his commissioned works – the portraits and allegories – were done in the studio on the basis of painstaking preparatory compositional studies, which under the normal Klimt regime meant a great deal of hard work, he painted all the landscapes during his 'free' summer months – and simply because he wanted to. From 1900 on, he spent virtually every year with his partner Emilie Flöge by the Attersee in the Salzkammergut region of north-west Austria. A few landscapes were also painted beside Lake Garda in Italy, in Golling near Salzburg, and at St Agatha. One picture was painted at Bad Gastein, and one in the park at Schönbrunn – Klimt roamed around this park every morning, if he could, walking there being one of his greatest pleasures. The landscapes are, with a few exceptions, square: Klimt's favorite format, and one he popularized at the Secession. Over these squares he would paint dense patches of landscape – orchards,

meadows, buildings, clumps of trees, and carpets of flowers. There were also water scenes, but no panoramas, no extensive views of broad plains, no distant mountains. The landscapes have a peculiarly flat look, due largely to the fact that he used opera glasses or a piece of cardboard with a square hole cut out of it to frame the scene he wanted to paint. The result: compacted structures arranged in a series of planes. Spatial depth did not interest Klimt in either his portraits or his landscapes. Only in his early days did he occasionally use space, but later it played no part at all in his art.

Klimt was familiar with the main trends in European art, had seen Van Gogh's intense landscapes, and knew works by Monet and the Neo-Impressionists. He used such sources as inspiration, but in the final analysis always stuck to his own very personal style.

What distinguishes Klimt's landscapes above all is the total lack of people. Not a single picture has someone strolling, a child playing, or farm laborers at work. This characteristic gives them an extraordinarily peaceful and calm air, exuding a wonderful inwardness.

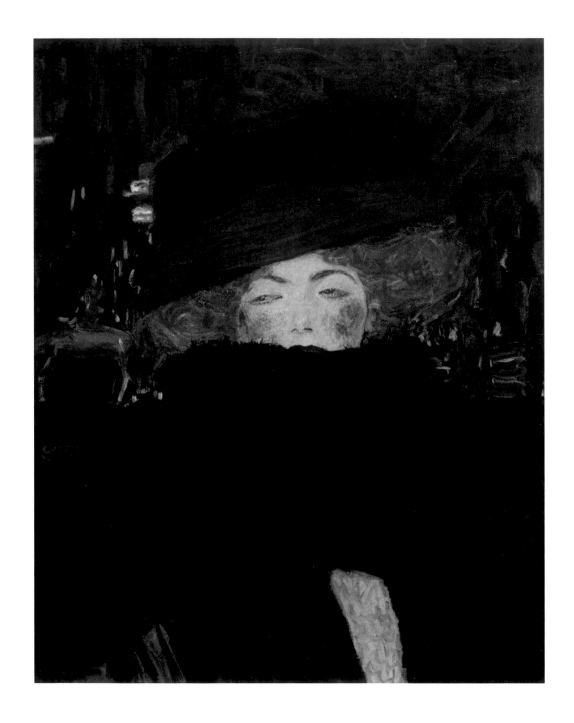

Lady with hat and feather boa Klimt painted this enigmatic woman just over two years after *The Kiss* (opposite). The influence of young Viennese artists Kokoschka and Schiele can be seen – all the gold, the rich ornamentation and the decorative flourishes have been abandoned. The picture is plainer, more Expressionist – and seemingly full of secrets and hints.

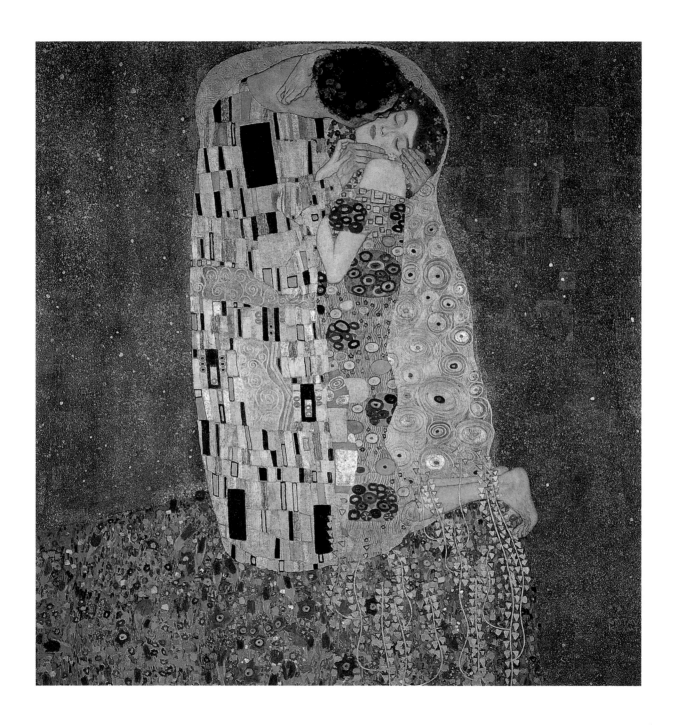

The Kiss This fascinating picture is one of the high points of Klimt's art. Is the man Klimt himself, and the woman his friend Emilie Flöge? It is at any rate a wonderful allegory about the power of love to draw lovers out of their individuality and merge them with another person, and with the universe.

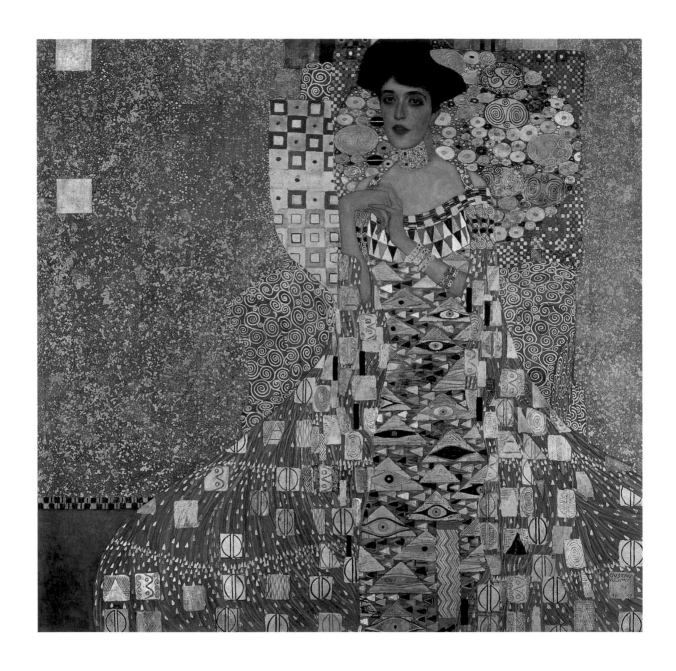

The Gold Period *"Mehr Blech als Bloch!"* (More metal than Bloch) was a popular saying in Vienna about Klimt's first *Portrait of Adele Bloch-Bauer I*. It is his most famous portrait and the culmination of his Gold Period. It is a superb combination of realistic portraiture and abstraction. The decorative motifs on the dress (such as the Egyptian 'eye in a triangle') can be seen as exotic symbols.

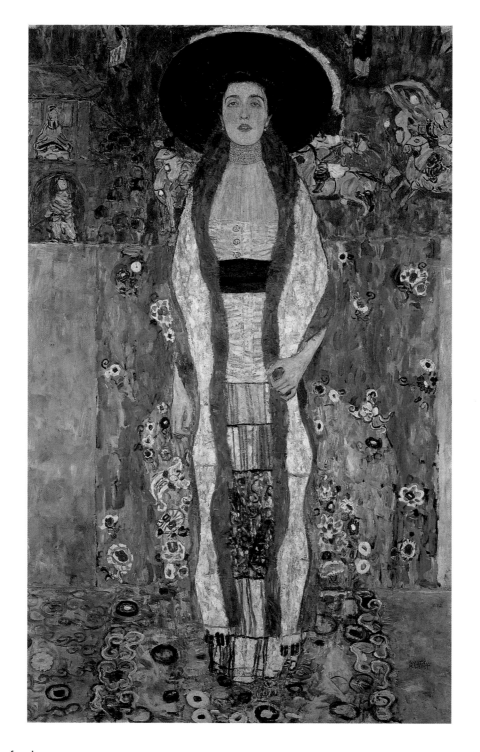

High point of color Apart from Emilie Flöge, Adele Bloch-Bauer was the only woman whose portrait Klimt painted several times. However, in the second portrait, color takes the place of gold. It is almost certain that the first *Judith* also immortalizes Adele (page 104). The sitter – the wife of a rich industrialist – was his lover for several years.

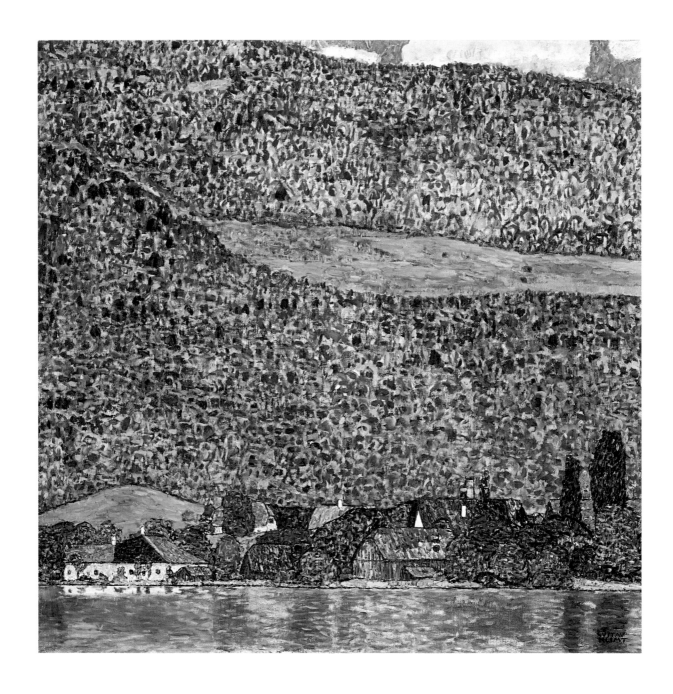

A glimpse of sky A rare moment in Klimt's landscapes – generally he was not interested in deep perspective, but in this picture, painted from the middle of a lake, the small patch of blue sky adds a tantalizing suggestion of depth.

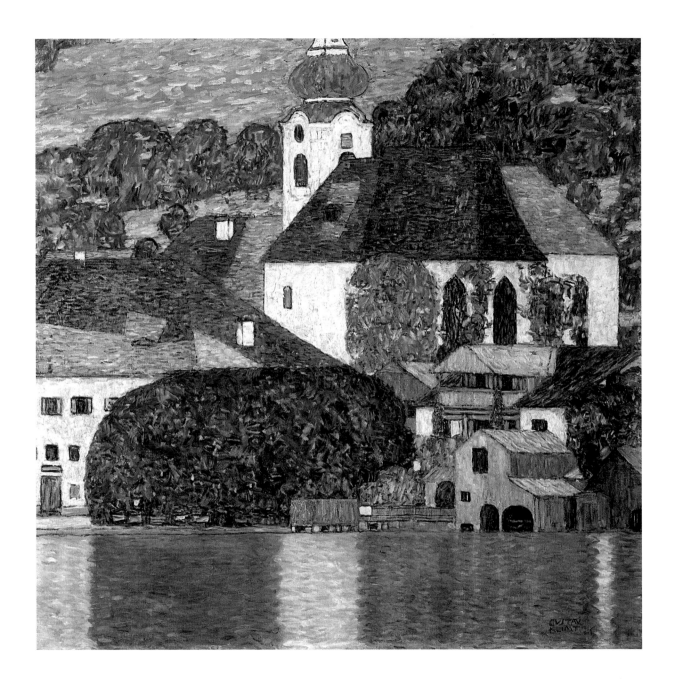

Unterach on Attersee Here the buildings are 'stacked up' close behind one another on the shore of the lake. The square format – a shape that was considered particularly harmonious by mystical thinkers – limited the choice of how to fame the scene, so some buildings had to be cropped.

Life

"I'm convinced
I'm not a
particularly
interesting
person."

Gustav Klimt

A forceful personality

Klimt came across as a strong personality in the Vienna of his day. He was blessed with great talent, to which were allied ambition, a hunger for work, and strict discipline. Klimt did not think he was particularly interesting as a person, and referred people to his works instead. Anyone who wanted to know about him, he said, "should look closely at my paintings and try to see in them what I am and what I want."

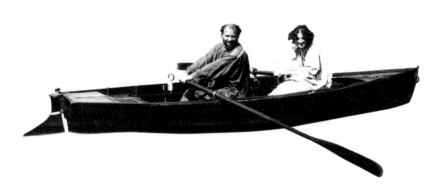

Time off

Relaxation did not come easily to Klimt. He had to take a positive decision when he wanted time off from his commitments. Not that he had anything against distractions. Above all, he felt, they should be *fun*. As a bachelor in Vienna, he loved the traditional trio of wine, women and song – as well as walks in Schönbrunn Park and the occasional game of ten-pins. He was also fond of a leisurely breakfast with coffee, *gugelhupf* cake, and whipped cream. And fitness was not forgotten – Klimt was a keen oarsman and fencer, he exercised and swam regularly, especially in the Attersee during his vacations.

We know that Klimt ...

--➔ loved cats.

--➔ lived happily with his mother and sister all his life.

--➔ supported his mother and his sister-in-law and her child.

--➔ enjoyed the company of friends, though he rather liked being considered a solitary artist.

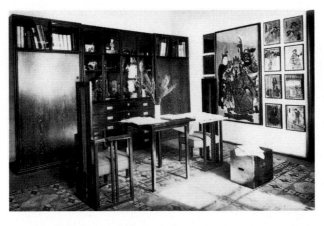

His garden

In his last studio, Klimt laid out a splendid garden in the overgrown style of utilitarian flower gardens of late Victorian times. It was a green oasis for him. He filled it with plants and replanted the beds every year. He was especially fond of the colorful flowerbeds. Many of Klimt's landscapes bear witness to his love of flowers.

His special retreat

For his work, Klimt needed uninterrupted peace and seclusion. He maintained a studio in Vienna, the location of which changed a number of times during his career. The last one was in the Hietzing district of Vienna, which was still on the fringe of the city at the time, though it is now swallowed up by city sprawl. Schiele also worked in the immediate vicinity. Klimt's studio was not only a place of work, but also a place of retreat, and was set up to be lived in. The furniture was by Josef Hoffmann and there were Japanese prints on the walls.

"No comment!"

Klimt said nothing in public about his private life. And of course that made it all the more interesting. A tissue of gossip, wild speculation, and ill-founded rumors became associated with his name, particularly over his relationships and love affairs. It was only after his death that sources were discovered that have gradually provided a truer picture of Klimt the man.

Summer vacations

In times of increasing prosperity and mobility, it became more and more the done thing for prosperous middle-class families to go away on vacation. Apart from educational trips and visits to health spas, summer vacations in the country became very popular. From 1897, Klimt and the Flöge family went almost every summer to the Attersee in the Salzkammergut region in north Austria, where he spent relaxing months painting landscapes. Other artists, musicians and writers, notably Gustav Mahler and Arthur Schnitzler, also went to the country in the hope of finding fresh inspiration – in Mahler's case, it was likewise to the Salzkammergut.

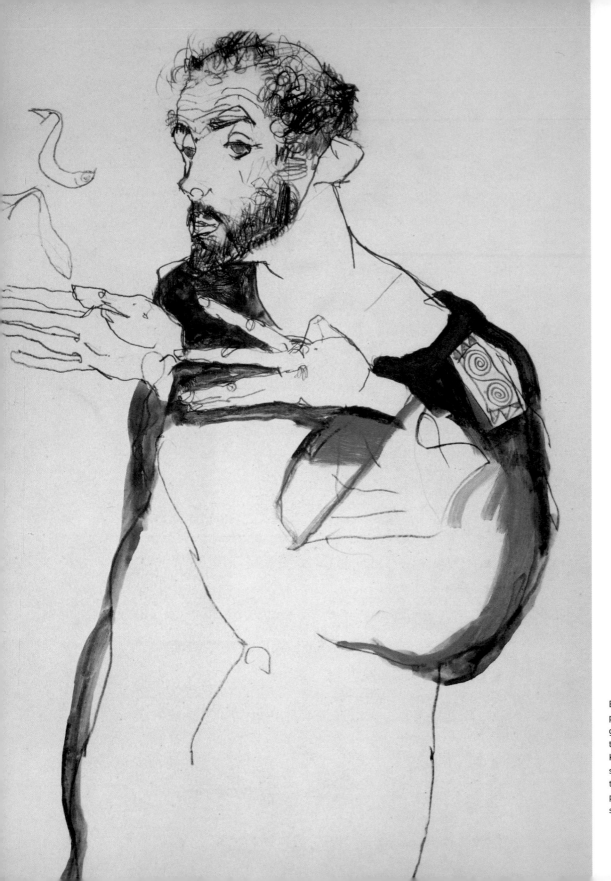

Egon Schiele portrayed his great inspiration Gustav Klimt, who is shown in his typical blue painter's smock, *c.* 1912.

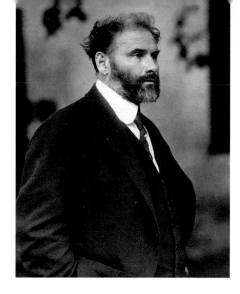

Photographer Moritz Nähr was a lifelong friend of Klimt. Nähr took this photograph of the painter *c.* 1910.

"A man of rare profundity."

Klimt was at one with life. He had no quarrel with fate, and never complained about his life. He was ambitious, and worked his way up the professional ladder with great application; and once free from material worries, he was able to live exactly as he wanted to. He was not discouraged by criticism. Without needing to adapt, he found ways to arrange things to his advantage. What he wanted above all else was simply to paint.

Humble origins

Gustav Klimt was born in Baumgarten near Vienna on 14 July 1862. At the time, it was a separate village, only being absorbed into the city as the 14th district of Vienna when the city boundaries were hugely extended in 1892. His parents Ernst and Anna Klimt were poor and often struggled to provide the family with the bare essentials. Although the artist's grand-father had made it to the ranks of Emperor Ferdinand I's bodyguards, the Klimts, who originally came from the Elbe region of Bohemia, were generally peasants or soldiers.

> "Anyone who wants to know about me ... should look closely at my paintings and try to see in them what I am and what I want."
>
> **Gustav Klimt**

This house at Linzerstrasse 247 (now in Vienna's 14th district) was where Gustav Klimt was born. The Klimts occupied the room immediately to the right of the entrance. The photograph dates from 1900. The building was demolished in 1967.

Back in Drabschitz, near Leitmeritz in Bohemia, the prospects of making a living had not exactly been rosy. Ernst's father's position at court in Vienna was the only ray of light. So Ernst Klimt moved with his parents to Baumgarten when he was eight. Young Ernst learnt the trade of engraver, and married Anna Finster, who was two years older and dreamt of becoming an opera singer. It was a dream that soon evaporated – the young family rapidly expanded until there were seven children to provide for.

Hard times

The first child was Klara, with Gustav following two years later. The rest followed at intervals of a year or two: Ernst, with whom Gustav shared a career for a while, Hermine, Georg, Anna, and finally Johanna. Anna survived only till she was five.

Most of the time, this large family lived in the confined space of a single room. Ernst, the father, was not blessed with much business sense. Even though he worked honestly and hard, money was always tight.

After the stock exchange crash of 1873, the family was almost destitute. Christmas that year was a very sad affair. One of Gustav's sisters remembers: "We didn't even have bread, let alone presents." They were often unable to pay the rent, and so the family was left with no choice but to keep moving. This life of semi-vagrancy was quite normal in the suburbs of Vienna, where factory workers and the unemployed lived.

His training begins

In 1867, the Klimts moved to Vienna's 7th district, and one year later Gustav started school. He went to the municipal school, leaving at fourteen with a very good graduation certificate. All his teachers agreed – this lad has artistic talent. Gustav was advised to try for the School of Arts and Crafts. The school had been in existence for only ten years at the time, and was run on the model of a modern art school in London.

So Klimt went in for the entrance examination. At the desk next to him sat Franz Matsch, later to be his friend and colleague in the Künstler Compagnie trio. Both lads

The building where Klimt
learned his trade – the
College of Arts and Crafts and
Museum of Art and Industry,
on Vienna's Ringstrasse,
photographed *c*. 1900.

passed the examination – Klimt had to draw a female head – and were even given scholarships. That did much for the family finances. A year later, Gustav's brother Ernst was also accepted for the School of Arts and Crafts. Ernst, Gustav and Franz made a good team, and soon their teacher, Michael Rieser, gave them commissions transferring designs to larger formats. Franz Matsch was very appreciative of the extra income Rieser's commissions provided: "We were very glad of it, particularly as he always paid us well. From then on, things went better for us – for the Klimts especially, it was a real blessing."

Early successes

During their three-year training, the students did a lot of work with classical subjects and models, an influence that marked Klimt's work all his life. When they registered for the state examination for drawing teachers at secondary schools, something happened that change the life of all three of them. A court coun-selor called Eitelberger visited the class and was particularly interested in the work of the Klimt brothers and Matsch. "Probably Rieser had drawn Eitelberger's attention to us," observed Franz. "He had a thorough look at all our things. 'Drawing masters?' he asked, and shook his head. 'You must become painters.' Each of us got a scholarship of twenty florins, and we transferred to the painting and decorative art department under Professor Ferdinand Laufberger."

Laufberger was professor of figure drawing, and was also expert in techniques such as *sgraffito*, a form of fresco painting. He taught his pupils how to make good use of decorative painting in architectural contexts, notably in murals. Laufberger immediately realized the enormous talent of the trio and soon had them working with him on his public commissions. He hoped that the Klimt brothers and Franz Matsch would one day continue his work. The three of them benefited first and foremost financially – during their time in the painting classes they did medical illustrations for audiologist Adam Pollitzer, and painted portraits from photographs, at six florins a time. The next step was to acquire a

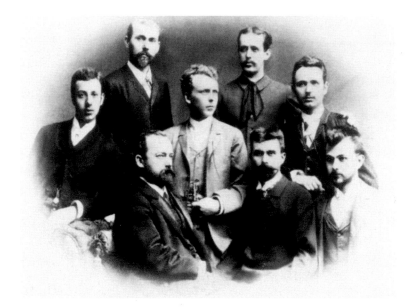

The class of 1880: Professor Laufberger sits front left, with Gustav and Ernst Klimt beside him. Franz Matsch is in a dark suit at the back.

studio of their own so as to be able to take on the commissions that Laufberger obtained for them. As part of these commissions, they even worked for the leading Viennese painter of the day, Hans Makart – a fact that boosted the trio's reputation enormously, and from 1881 they called themselves the Künstler Compagnie (Artists' Company). Gustav Klimt was just nineteen at the time.

Entrepreneurial spirit

For ten years, the Künstler Compagnie was a very profitable business. The trio's boast was that they could carry out commissions very quickly, as they had specialized enough to dovetail their individual styles down to the fine details. "Like a single hand," it was said, or "Indistinguishable!" Matsch and the Klimts considered themselves purely decorative painters, with Matsch as the head of the team, looking after the money and searching for new projects.

Other important commissions were the decoration of the new Burgtheater and the Kunsthistorisches Museum. In 1884, Hans Makart, who had actually been commissioned to do the work, died quite suddenly, and it was a case of finding someone who could finish the job quickly. It was a job tailor-made for the Künstler Compagnie (pages 20 and 21).

Models needed

The Künstler Compagnie needed a large number of models for their commissioned work. As these were often expensive, the trio asked friends and family to help out. From time to time the artists themselves also assisted by sitting for each other. For example, in the *Shakespeare's Theater* series, we find not only the Empress, Sissi (page 7), but also the members of the Künstler Compagnie, which meant that Gustav Klimt, if

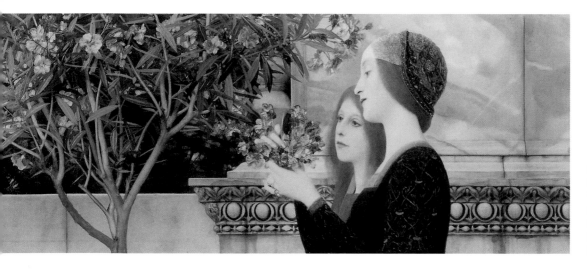

Klimt painted *Two Girls with Oleander* in 1890–1892. This early work, depicting a scene from Antiquity, is in the then popular Neo-classical vein.

unintentionally, did at least one self-portrait. The commission was a complete success, and the three young men were even awarded the great *Verdienstkreuz* (Order of Merit). The next job came on the heels of the first one – to record for posterity the interior of the old Burgtheater in Michaelerplatz, which was earmarked for demolition. Franz Matsch painted the view of the stage, Gustav Klimt the view of the auditorium (page 9). The commission stipulated that around 250 prominent Viennese citizens should be portrayed in the picture. The painters had no need to contact Viennese families to get sitters. After the city announced the scheme, the artists were besieged with enquiries and offers. Everyone wanted to be immortalized.

Happy days

The trio had made it socially. The young painters were awarded the Imperial Grand Prize for the Burgtheater pictures, and they were admitted to the guild of established painters. Their careers were progressing well. There was even room for private happiness – in

Like many other members of the Klimt family, Gustav and Ernst's brother Georg was called in to act as model, in this case Romeo in a test photograph for one of the the *Shakespeare's Theater* paintings.

1891, Ernst, born into poverty, married Helene, the daughter of well-to-do Ernst Flöge, who manufactured meerschaum pipes. This connection finally established the Klimt brothers in Vienna's upper middle class. It also brought Gustav into contact with Helene's sister Emilie, allowing him to develop a natural friendship with her, since the acquaintance was 'legitimized' by the marriage of her sister.

A tragic turn

After so much good fortune, fate immediately dealt the Klimts some savage blows. In 1892, Klimt's father and the newly married Ernst both died in quick succession.

In 1918, after Klimt's death, his nephew Julius
Zimpel painted a watercolor of his uncle's room:
a neat and tidy bachelor's apartment, lightly fur-
nished and with just a few pictures on the walls.

Klimt lived in this building at
Westbahnstrasse 36 with his
family. His room was the two
third-floor windows on the left.

Gustav was now financially
responsible for his mother,
his sisters, and his sister-
in-law and her daughter.
Ernst's death likewise put
an end to the Künstler
Compagnie, since Gustav
could no longer accept being merely an assistant
decorative painter.

The deaths involved one final move for the remaining
Klimts (Gustav, his sisters Hermine and Klara, and their
mother, Anna), this time to Westbahnstrasse 36 in the
7th district of Vienna, only a few doors from the Flöge
family.

The new family apartment was on the third floor, not the
piano nobile (fashionable first floor), and here Gustav
lived in a room that he would occupy for the rest of his
life. After Klimt's death, his nephew Julius did a
watercolor of it. It was modest accommodation. It had
just a bed, a cupboard, a washstand and a sofa, and only
a few pictures on the walls. This plain interior fitted well

with the image of him that his sister Hermine created –
she said he was very domestic and spent almost every
evening with the family; after meals, which he would eat
more or less in silence, he would soon go to bed so as
to be able to get up early in the morning and go off to his
studio. This impression of the retiring artist was
something that Hermine and Klimt himself projected
time and again. He was very anxious to keep his private
life private, and if that was not possible, to represent it
as very ordinary. Did he want to hide the 'other' Klimt,
the other life he led, or did the Klimts wish to conform
with public decency, at least outwardly?

A very private studio

In fact, interesting things did go on, particularly in
Klimt's studio. It was his second home, his real
environment. After he broke with Matsch, and again
later when he left the Secession, the studio became the
focal point of his life and work.

From the early 1880s, when Klimt had first been able to
afford a studio of his own, he had made his studio a

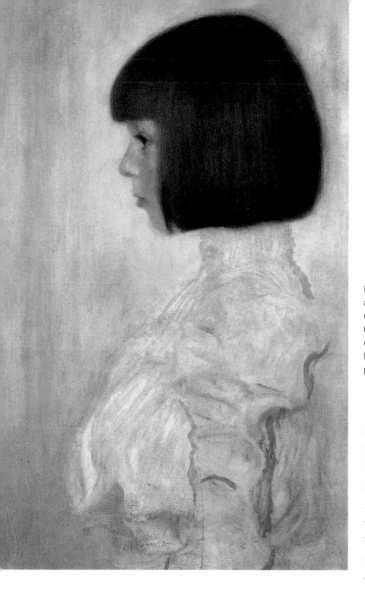

Helene, the daughter of Ernst and Helene Klimt, was just a few months old when her father died. Gustav became her guardian, and cherished and looked after her financially all his life. In this picture, young Helene is six.

special place – but in a different way from (for example) his predecessor Hans Makart. The latter had set up an extremely showy studio, where he often invited guests and organized opulent fancy dress parties, as in a story from the *Arabian Nights*.

Klimt's studios were quite different. He moved from the fourth floor of Sandwirtgasse 8 to the garden pavilion of Josefstädterstrasse 21, and finally in 1911 went from there to Feldmühlgasse 15a, where his last studio is still preserved. Thanks to photographer Moritz Nähr, and a description by Egon Schiele, we have a clear impression of Klimt's last studio. The little cottage was soberly but

tastefully furnished, and had an inviting garden in front of it for walking and thinking. Shortly after Klimt died, Schiele wrote of it: "It was in a garden – one of the old, hidden gardens of which there are so many in Josephstadt – that had a low cottage with several windows, and was surrounded by tall trees at the end. You walked between flowers and ivy to reach it. That was Klimt's workplace for many years. Outside the door were two lovely heads sculpted by Klimt.

You passed though the glazed outer door into a lobby, where stretched canvases and other painting materials were stacked up. This adjoined three other rooms, the one to the left leading to a reception room. In the middle was a square table, and round the room Japanese woodcuts and two larger Chinese pictures hung side by side. On the floor were Negro sculptures, and in the corner beside the window was a set of red and black Japanese armor. From this room you accessed the two other rooms, where there was a view of rose trees ... and ... where [in one of them] two skeletons had been set up. Then there was another room, the long wall of which

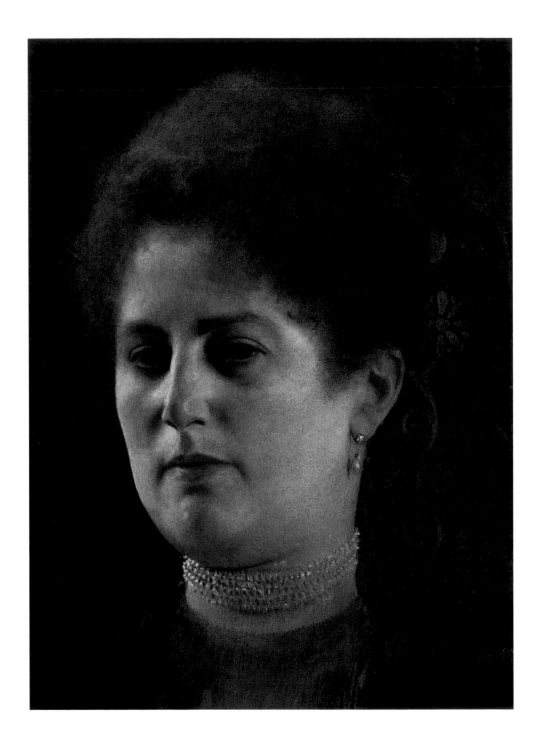

Portrait of a lady Who Klimt painted in this picture remains unknown. It was done in 1894, at a time when Klimt was increasingly busy with portraits for private patrons. The death of his brother two years earlier had made him the sole breadwinner for a large family, and he was happy to take on commissions to boost his income.

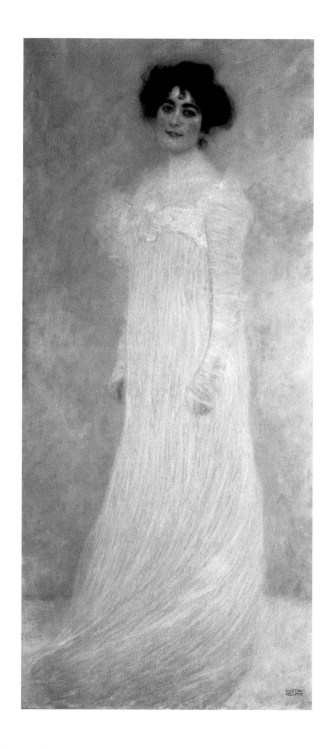

An aura of serene charm In 1899, Klimt painted Serena, wife of the rich industrialist August Lederer. Lederer was an enthusiastic patron of Klimt, and soon owned the largest private collection of his works. In this larger-than-life painting, Serena looks tender and charming. Elegantly caressed by a softly falling gown, she almost blends into the light background.

The pianist Composer and pianist Joseph Pembauer was the founder of the Pembauer Society, to which artists and actors (including the Klimt brothers) belonged. This portrait of Pembauer from 1890 was destined for the room where the society used to meet. The ornate frame and decorative background bring out the power of the portrait strongly.

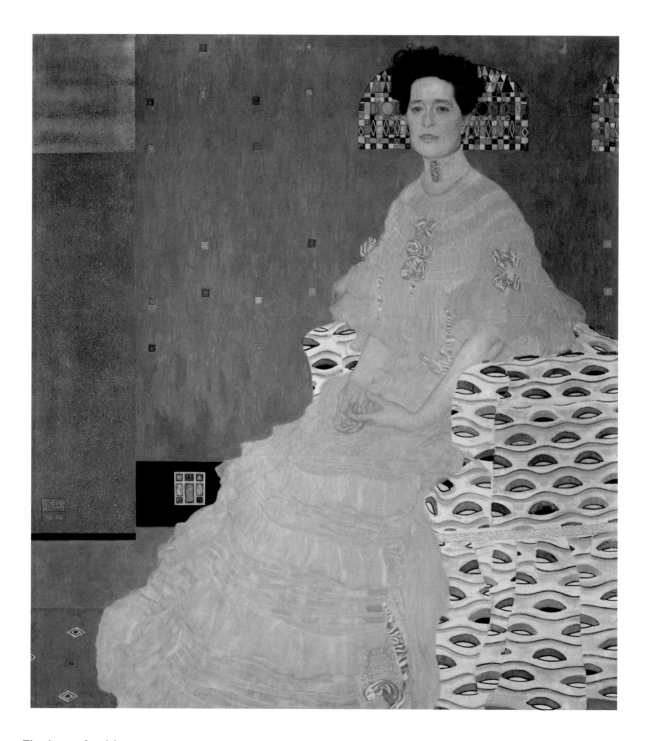

The love of gold With this *Portrait of Fritza Riedler*, Klimt embarked on his so-called Gold Period. Fritza is shown formally integrated into the abstract and ornamental chair in which she sits. With her erect, attentive pose, faraway look and relaxed hands, she looks like a pensive young girl.

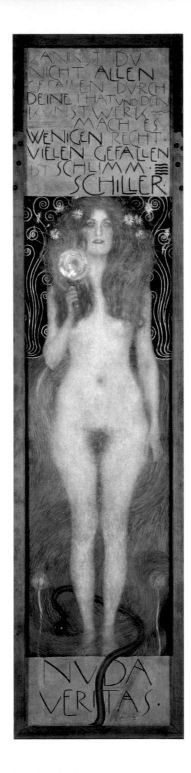

The naked truth *Nuda Veritas* of 1899 symbolizes what the Secessionist artists were aiming for – a direct and uncompromising art concerned above all with 'the truth.' The nude female figure, the embodiment of this *veritas*, holds up a mirror to viewers, a challenge to test their own truthfulness.

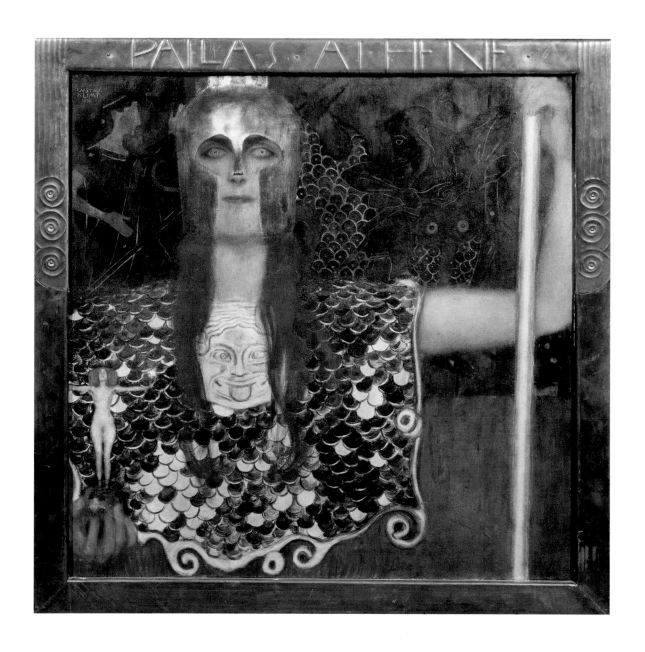

Pallas Athene The task of the Greek goddess was to stand guard over Vienna's artists. Pallas Athene, elected the Secession's patron goddess, stands watchful and militant. An ornamental frame encloses a somewhat unusual view halfway between a bust and half-length portrait. In this 1898 picture, Klimt endows the goddess of war, wisdom, and the arts with an air of mystery and seduction.

Klimt's studio. The overgrown garden turned his refuge into a haven of nature.

had only a large wardrobe built into it with lovely Chinese and Japanese clothes.

From here you entered the ... studio itself. Klimt always wore a full-length blue smock with ample folds. That's how he came out to meet visitors and models knocking at the glass door."

Models and muses

The visitors who knocked at the door of Klimt's studio were rarer than the models he needed for his works. Along with designs for his compositions, he also did countless sketches of a highly erotic nature – which explains only too well why he didn't like to be disturbed in the studio. The way women in his public pictures

displayed themselves was provocative enough for the time, but in the drawings the poses were completely uninhibited.

It is quite certain that Klimt had sexual relationships with his models. He acknowledged the paternity of three sons. He worked regularly with several models, and seems to have had open relationships with some of them. One was Maria Ucicka, mother of his openly acknowledged son Gustav. Another was Mizzi Zimmermann, with whom he had sons Gustav and Otto. She was probably the one portrayed in *Hope I* and other drawings of pregnant women. Klimt's affair with Mizzi lasted until about 1903, but it was certainly not a love affair. However, Mizzi did feature in Klimt's life at the time. He did not like writing, but sent her letters from his summer vacations and asked after the children, for whom he provided financial support. But he also provided for other models who waited in his studio every day for the painter to draw them.

In the periodical *Der Merker*, writer and journalist Franz Servaes described the scene in Klimt's studio, to the

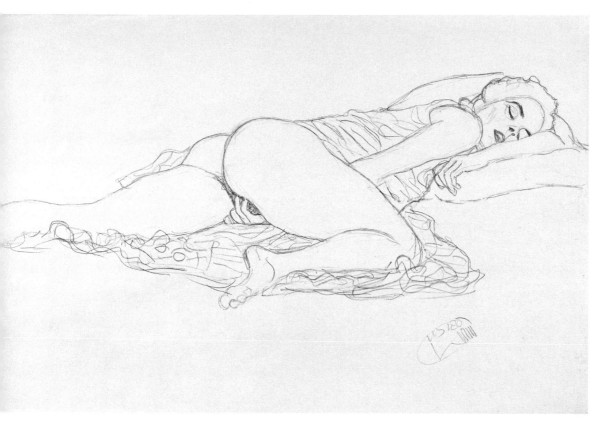

Klimt did numerous erotic drawings of his models.

delight and horror of Viennese society: "Here he was, surrounded by mysterious naked female creatures who, while he stood mute at his easel, walked up and down in the studio, lolled about and loafed around and whiled the day away – always ready for a nod from the master to stand obediently still as soon as he caught sight of a position or movement that pleased his sense of beauty, and which he could record with a quick drawing."

One woman for life

Klimt did not enter any monogamous relationship – he never married, had numerous affairs, and after his death fourteen claims were made on his estate for putative mothers and children.

As colorful as his amorous and sexual adventures may have been, in his own way he remained faithful to one woman all his life – Emilie Flöge.

We can confidently look on Emilie as Klimt's lifelong partner. Twelve years younger than he was, she became his foundation, his point of reference. It was not a relationship that was transparent to outsiders. It is still a matter of debate whether they were merely platonic friends or lovers. Klimt officially painted his 'Midi,' as he like to call here, three times. How many other pictures

Mizzi Zimmermann. She was not only Klimt's model and lover, but also the mother of two of his children, Gustav and Otto.

sisters. Society ladies got their fashions from the Flöge sisters, and Emilie exercised her creative energies by designing clothes in the new, freer style seen in many of Klimt's portraits. She was keenly interested in fashion, and enjoyed wearing the extravagant designs of their salon. At the turn of the century, emancipation was already underway, and the way of life Emilie chose for herself was indeed very 'modern.'

Emilie features in is still a matter of speculation. After Klimt's death, Emilie Flöge did not marry anyone else, and we know of no other love affair on her side – she was Gustav's companion to the end of his life. Emilie was financially independent and was socially one of the 'better classes.' That also enabled her to determine for herself the way she wanted to live. She was creative, and ran a flourishing fashion business with her

That Klimt and Emilie consciously opted for this kind of self-determined life may very well have been the reason why they never married. The leading fashion designer and the celebrated painter were intimate. A correspondence of hundreds of postcards and letters shows that they were a part of each other's everyday life, and appeared in public together often, whether at the theater, exhibition openings, or among friends.

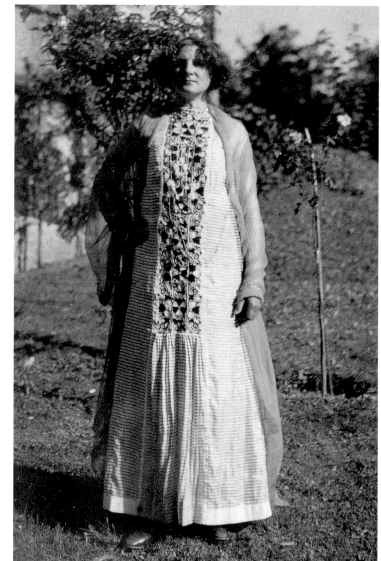

Fashion designer Emilie Flöge was part of Klimt's life to the very end, his confidante, friend and partner.

"Attersee is heaven!"

Gustav also spent most of his treasured summer vacations with Emilie. St Agatha and Golling were among their first destinations, but from 1900, Attersee in the Salzkammergut became their favorite resort. Once, in 1913, they went to Lake Garda in Italy, but otherwise the two of them – and their families – looked forward to the weeks they spent at the Brauhof Litzlberg, the Villa Oleander in Kammer, or in Weissenbach. And every year they visited Emilie's relatives at the Villa Paulick in Seewalchen. Klimt often remained a few weeks longer in Vienna before following Emilie – and until that day, he wrote postcards telling of his preparations for the journey and his anticipation: "Have already packed a lot – only needs putting in the case." Though relaxation, company, and sport were on the agenda, once he he had gotten settled, Klimt worked hard during the summer months, painting landscapes and also working on his major

commissions, and he had a strict schedule for every day. Klimt was full of energy and had no time for idleness. His letters to his model Mizzi Zimmermann describe the course of his day in detail:

"You ask for a kind of timetable about how I spend the day. Well, my life here is very simple and regular. I get up early, generally around six, or a little earlier or later. If the weather's nice, I go to the woods – I paint a little beech wood there (in the sunlight) with a few fir trees in

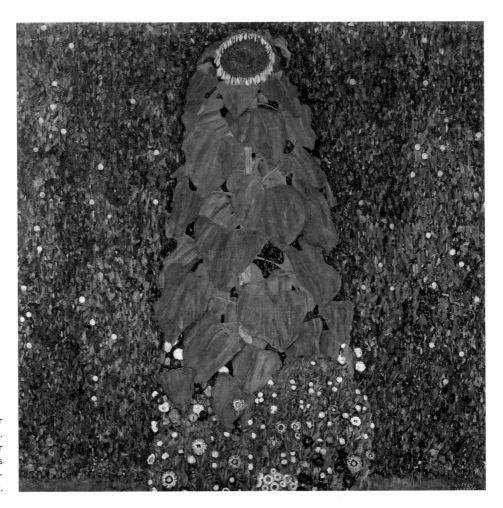

This picture of a sunflower is made up like a mosaic. Klimt painted the flower the way he painted his women: immobile, self-contained, radiant.

it here and there, which takes until eight, then comes breakfast. After that comes a swim, with all due precaution – thereafter a bit of painting again, if the sun's shining a picture of the lake, or in dull weather a landscape from the window of my room – sometimes I don't paint before lunch, but instead study my Japanese books – outside in the open. Then it's lunch time, and after lunch there's a brief nap or a bit of reading – until it's time for a snack, before or after which comes a second swim, not inevitably but usually. After the snack there's more painting – a large poplar in the twilight with a storm on the way. Now and then instead of this evening painting there's a small ten-pin bowling party in a nearby village – but not often – then supper, and early to bed and early out of bed in the morning. From time to time, a little rowing is slotted into this schedule so as to tone up the muscles. This is how it goes day after day. Two weeks have already passed, part of the vacation is already over, and it'll be a pleasure to return to Vienna again."

While painting, Klimt hated to be disturbed. In his last years, he retreated to a secluded forester's lodge near

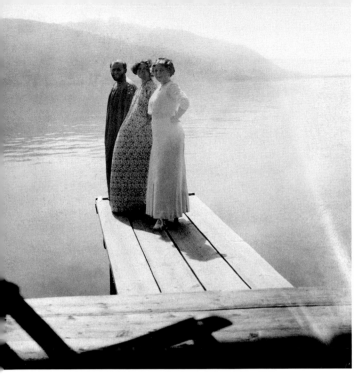

Gustav Klimt with Emilie Flöge and her sister Helene by the Attersee, *c.* 1905. The annual summer holiday was an important fixture in the artist's life.

Elaborate outings to the country, walks, and trips to inns were socially important components of Klimt's summer holidays. But he demanded absolute solitude when he was painting, and never even let himself be photographed working.

Weissenbach. The painter was a strange sight for other tourists as he silently dabbed at his canvas in all weathers, exotically dressed his long painting smock.

In the relatively short time available to him on his summer vacations, Klimt painted a large number of landscapes. These are becoming increasingly regarded as an important part of his output. In the past, they were largely ignored, but it is now appreciated more and more that these images of nature, completely devoid of people, open up new ways of looking at his other works. The compositions, the sense of form, and the choice of subjects in his other works must have been strongly influenced by his landscapes. Some see a link between the calm landscapes he brings to life and the women he allows to flower in his portraits.

The *Stoclet Frieze*

During his vacations, Klimt not only painted landscapes, he also worked on studio pictures he had brought with him from Vienna, commissions he had to complete. From 1905, for example, he started making pre-

parations for the *Stoclet Frieze*. Belgian industrialist Adolphe Stoclet, who lived in Vienna with his wife, had commissioned architect Josef Hoffmann to build him a house in Brussels, with Klimt taking on the interior

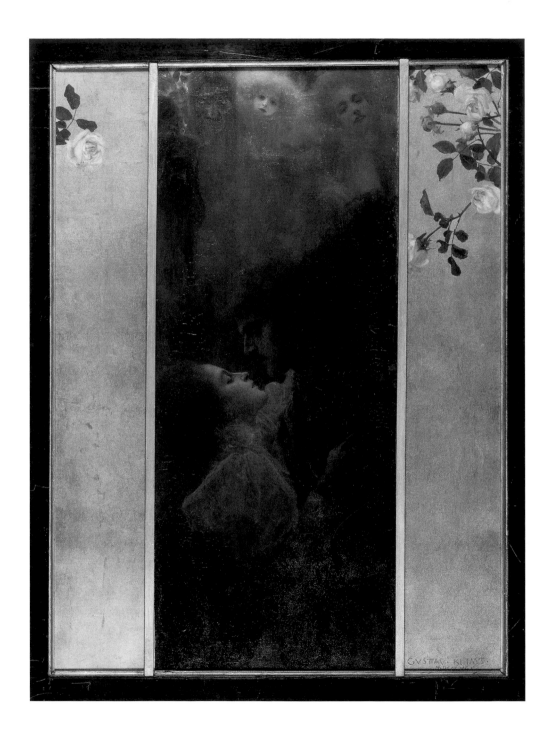

Romance This *Allegory of Love* from 1895 is often seen as an early precursor of his masterpiece *The Kiss* (page 41). Klimt became increasingly susceptible to Art Nouveau influence. The rose, a symbol of eternal love, is visible not only in the picture but also on the golden zones at the sides.

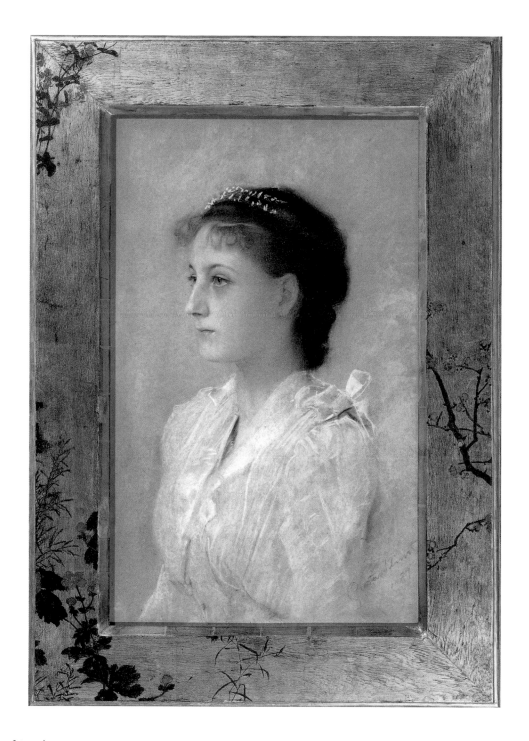

Bonds of tenderness Klimt did this portrait of Emilie Flöge when he first met her, in 1891, when she was seventeen. It was one of his first portraits. Emilie was the sister of his sister-in-law, Helene. Later, the two women and their third sister, Pauline, ran the Flöge Fashion Salon, a successful business designing and producing their own fashions for Viennese high society.

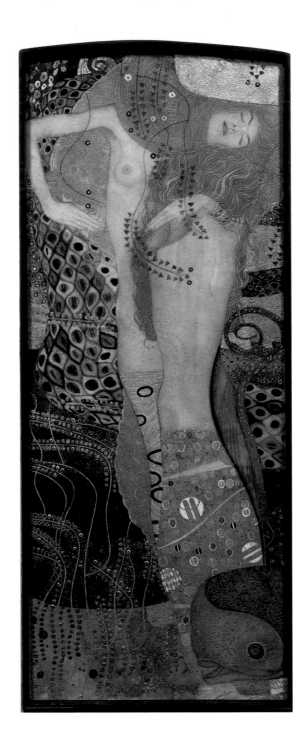

Lesbianism This painting clearly shows two women making love, though Klimt called the picture *Water Snakes I*. There are numerous scenes of women making love among Klimt's sketches, an intimacy he seems to have enjoyed as a spectator. The large-eyed fish at the bottom is perhaps a symbol for this male observer.

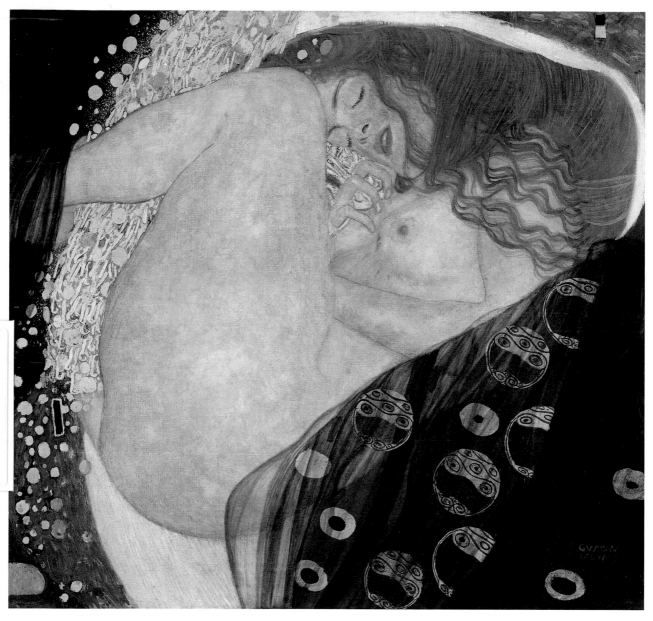

DR|

Rapt The imprisoned *Danae* is 'visited' by the god Zeus, who has changed himself into a golden shower. Klimt adopts the classical Greek myth in order to depict one of the most intimate moments of life. A torrent of gold threads pours forth between the red-head's thighs as she lies huddled up in fabrics that reinforce the image's erotic charge.

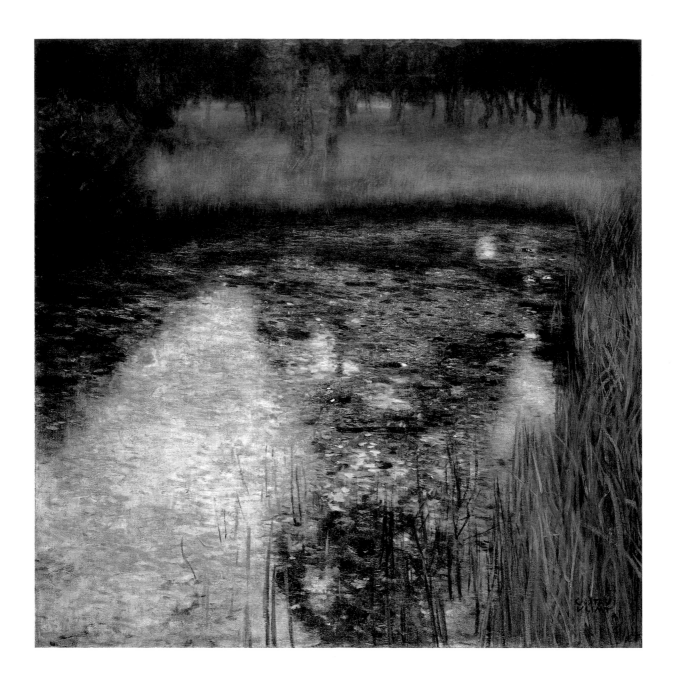

Mysterious marsh Klimt generally used a square format for his landscapes. In *The Marsh* he explored the subtle effects of color and texture. The surface of the water reflects the sky and surrounding marsh landscape like a mirror. The individual flecks of color provide vividness in an Impressionist manner, contributing to the almost mystical atmosphere of the picture.

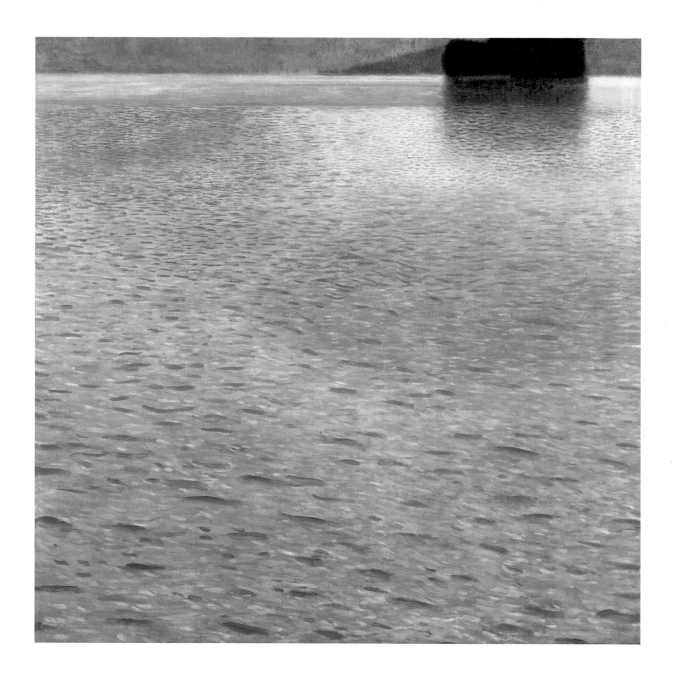

Beloved Attersee Klimt's love of nature, plants and the weather is clear from his letters and postcards. "A resplendent sun has come out, almost making it a gala day," he wrote to Emilie. A favorite subject of his paintings was his beloved Attersee, a lake in northern Austria. Here he is in meditative vein as he gazes at the hypnotic surface of the water.

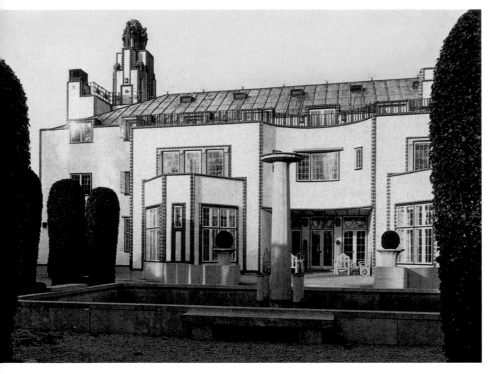

Klimt played an important role in decorating the new villa of industrialist Adolphe Stoclet in Brussels. The building was designed by architect Josef Hoffmann.

furnishing. Klimt worked for four years on designs for the frieze, which would be the last of its kind and a culmination of his Gold Period. It would also be a perfect *pièce de résistance* of the Secessionists' ideal – the different arts unified. Hoffmann designed the rooms as 'habitable cubes,' into which Klimt inserted the frieze, the dazzling heart of which is the Tree of Life. What the two of them achieved together would become the creed of the Bauhaus, and even the Russian Constructivists would work with the aim bringing the arts and the crafts into harmony. Indeed, it was an approach to design that would dominate the 20th century. The nine panels of the *Stoclet Frieze* include abstract, figurative, and decorative motifs, executed in mosaic. Klimt described the range of themes as "life, love, and death." The central motif is the Tree of Life, the symbol of the Golden Age. The dancing girl represents *Expectation*, the couple embraceing represent *Fulfillment*. The Stoclets' interest in Far Eastern themes and religions was well known. It was a passion Klimt had long shared, and had incorporated into his work. The *Stoclet Frieze* is a combination of his nature images and his depictions of man, a work symbolic of the reconciliation of the sexes, of domestic happiness, and of fulfillment in love.

In 1910, Klimt was very busy with the work on the cartoons for the *Stoclet Frieze* and therefore delayed his departure from Vienna on vacation: "What with the stupid thing for Brussels, I'd have to spend the whole summer here," he wrote to Emilie, who was already by the lake. He knew he could not escape the job: "I'll set off on Friday and try to get the Brussels job done in the

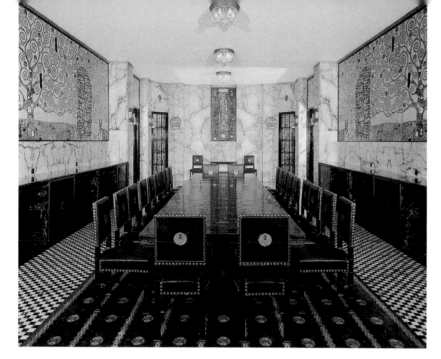

The *Stoclet Frieze* was designed for the dining room in the Palais Stoclet, Brussels, where the table could accommodate twenty-two people. Stoclet never revealed the costs of building the house, and even destroyed the relevant documents.

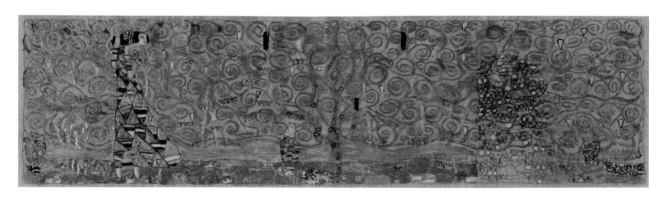

Parts of the *Stoclet Frieze*, as shown in Klimt's cartoon. There are no figures, and the frieze comes close to abstraction.

country. Unfortunately, I'll have to work very hard on the Stoclet, which is just what I need!" But four years later Gustav looked back at that work-filled summer quite differently. It seemed almost transfigured to him, and he recalled that Emilie had helped with the cartoons.

Home sweet home

Klimt loved to be at home, or in his usual summer setting by the Attersee, but trips abroad were sometimes necessary. He visited exhibitions and had to be present when commissions like the *Stoclet Frieze* were installed. He went abroad for the first time in 1890, going to Munich among other places, then in 1904 he also visited Ravenna, Florence and Venice, and in 1906 Brussels. Further trips came in 1909 and 1910 (Paris, Madrid and Prague) and 1911 (Rome and then Brussels again).

Though such travels made an impression on him – he was fascinated, for example, by Degas in France, and by the Byzantine mosaics in Ravenna – he was quite unable to leave Vienna for very long. He liked being at home in his studio.

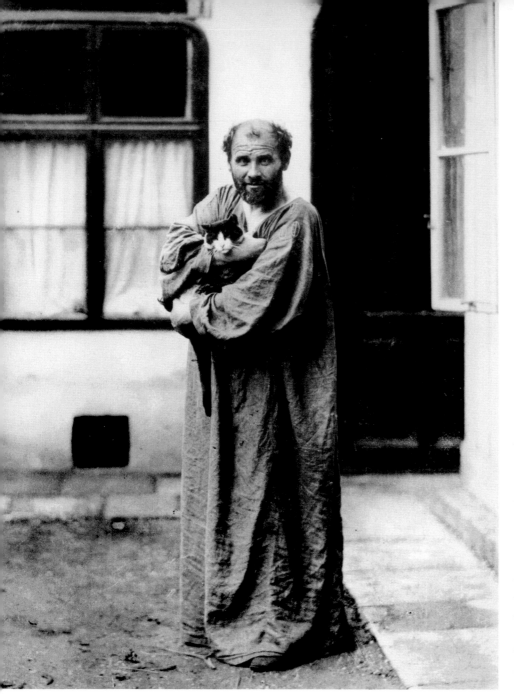

The artist outside his studio, posing with his cat.

Being abroad unsettled him and left him below par, as his many postcards show.

Keeping in touch

Postcards from Spain to his friend Carl Moll, to Emilie when she was in Paris, cards and letters to his model Mizzi in Vienna or his family by the Attersee – it is easy to get the impression Klimt was on fire to put down his thoughts in writing and share them with friends and relatives. It was probably simple courtesy, or more likely a longing for his friends and his familiar environment, that made him pick up his pen.

Klimt had a pronounced aversion to writing and to everything written. Often he left his post unopened for weeks – Emilie handled all his correspondence for him. He didn't even like phoning, and wanted to have as little to do with money matters as possible. "If the money rolls in, that's fine."

Despite an aversion to writing,
Klimt wrote countless postcards.
This one was to his sister, Anna.
The front contains the important
information, namely "Returning to
Vienna on Sunday."

Klimt's characteristic blue
painting smock is now preserved in
Vienna's historical museum.

Daily routine

At home in Vienna, Klimt could slip into his usual
routine. Very early in the morning, he always went to the
Tivoli Dairy in Meidling on foot to eat a hearty breakfast
of coffee and *guglhupf* cake with whipped cream. For
thirty years, he was accompanied there by his friend, the
photographer Moritz Nähr, and that's where close
acquaintances sought him out. After breakfast, he
walked to his studio. Once there, he did exercises and
gymnastics before getting down to work, from ten in the
morning till eight in the evening. In the evening,
according to his fellow artist Emil Pirchan, Klimt liked to
go to cafés were artists met, to play ten-pins, drink, and
eat a sizable supper. According to the art historian Alfred
Lichtwark: "Klimt was very fond of teasing people, and
frequently indulged himself in this diversion."

Premature farewell

Even World War I changed nothing in Klimt's daily life,
even though Austria was deeply involved in the conflict.

At fifty-six, Klimt suffered a stroke and died a few weeks later. His death mask shows him without his beard, which had been shaved off in hospital.

Klimt was not interested in politics and just went on living the way he always had. What did upset him deeply, and disrupted his routine, was the death of his mother in 1915. Klimt had always lived with her and his sisters, and her death now filtered through into his pictures – his palette darkened. But this did not stop him working on his favorite themes – the enigma of life, love, and women. And he continued to attend to his professional obligations. In 1916 he exhibited with the Berlin Secession, and a year later he became an honorary member of the art academies in Munich and Vienna. And he was still working with discipline and according to a set routine when death overtook him suddenly in 1918.

He was in his apartment on 11 January 1918 when he suffered a stroke. Paralyzed down one side, he was carried to a sanatorium. On 3 February he was moved to a general hospital, and died there of pneumonia on 6 February.

Four days later he was buried at the cemetery in Hietzing, where his grave is still to be found. The Viennese authorities wished to give him a ceremonial burial, but his family rejected the offer. They and Klimt's close friends were bitter that Klimt's death had elicited so little public tribute. This was largely because of the unfortunate date of his death: World War I was in its final stages, and negotiations between Austro-Hungary and the Ukraine and Russia seemed to be promising peace. Headlines about this filled the papers, pushing the reports about Klimt's death to the inside pages.

The funeral brought together the family, friends, patrons, and of course Emilie, as well as representatives of the Ministry of Education, directors of various Viennese museums, and artists and colleagues from

A light-hearted greeting in
a humorous vein – Klimt
in a self-caricature.

the Secession. Egon Schiele drew the dead Klimt and
published the work with the words: "Gustav Klimt / An
artist of incredible perfection / A man of rare profundity
/ his work a shrine." Klimt's death mask makes him
look odd – in hospital, his beard had been shaved off. In
the funeral speeches, his friends demanded that Vienna
erect a memorial to him as soon as possible. Schiele
hoped the studio would be saved for posterity. "His
friends should buy the house in Hietzing together with
the garden and furnishings – the house is a whole, a
work of art in itself."

However, because of the desperate housing shortage in
the post-war years, the house was let. The many
unfinished pictures and some 3,000 drawings were
divided up between Emilie and the family – who had in
turn to sell some of them because Gustav had left them
nothing. As a painter, he had earned a great deal, but he
never saved a penny.

Peter Altenberg wrote an obituary for his friend that
brings out the essence of Klimt's work and his genius:
"Gustav Klimt, you came close to the ideals of nature,
almost without knowing it, and even your simple but
noble peasant gardens with sunflowers and weeds
contain a breath of the creator's poetry. So you too kept
away from people who had no understanding thereof.
Gustav Klimt, *you* were fully human."

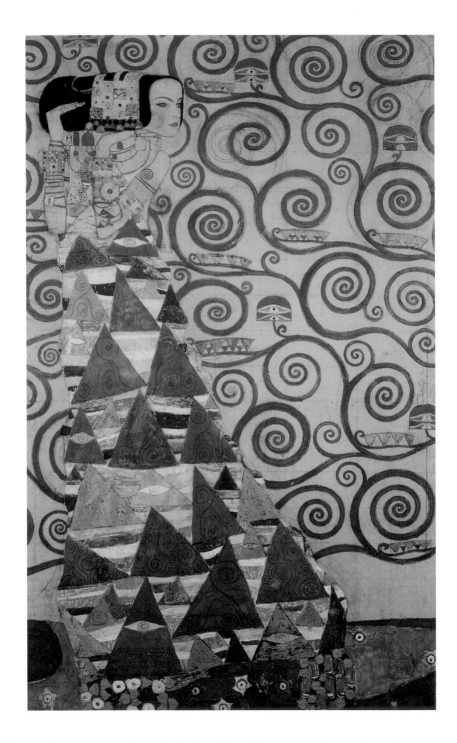

Expectation Klimt took five years over the designs for the *Stoclet Frieze*. The cartoons – this one is *Expectation* – were used by members of the arts and crafts association the Wiener Werkstätte (Vienna Workshop) to translate the pictures into mosaics. The Egyptian influence was strong here, notably in the use of profile and the position of the hands.

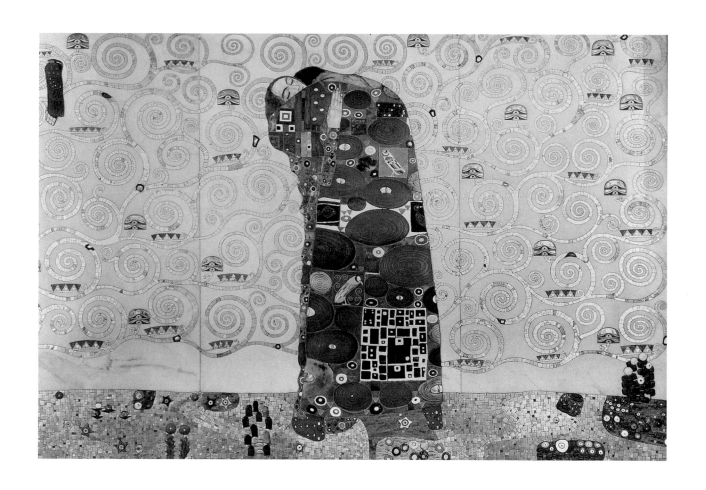

Fulfillment The *Stoclet Frieze* enabled Klimt to revel in his liking for the crafts. His cartoons were transferred to marble. Other materials were sheet copper and silver, coral, semi-precious stones, enamel, and gold mosaic. Klimt kept a close eye on the execution by the Wiener Werkstätte (Vienna Workshop). This is *Fulfillment*, which is installed opposite *Expectation* (opposite page).

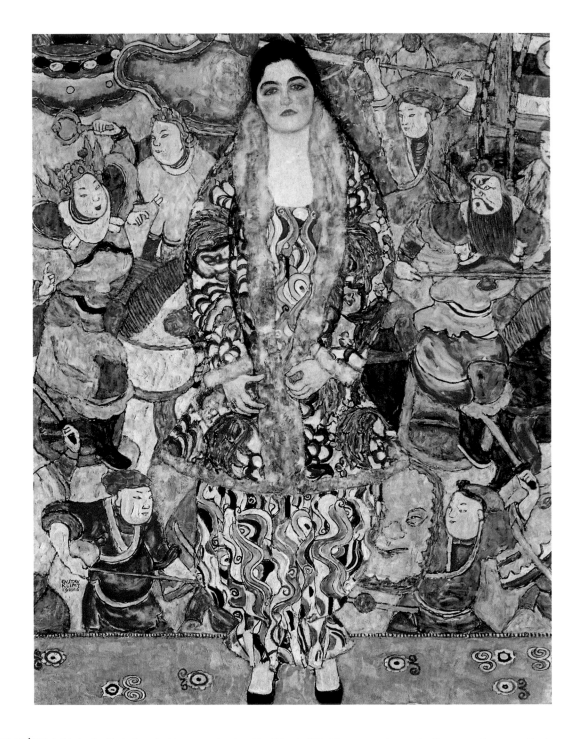

Japonisme Friederike Maria Beer had her portrait painted by Klimt in 1916. She was a patron of the Viennese art scene and had already been portrayed by Schiele. Rumor has it that, when asked by Klimt why she wanted a portrait by him as well as by Schiele, she said that only Klimt would make her immortal. The influence of Japanese art can be seen in the motifs in the background.

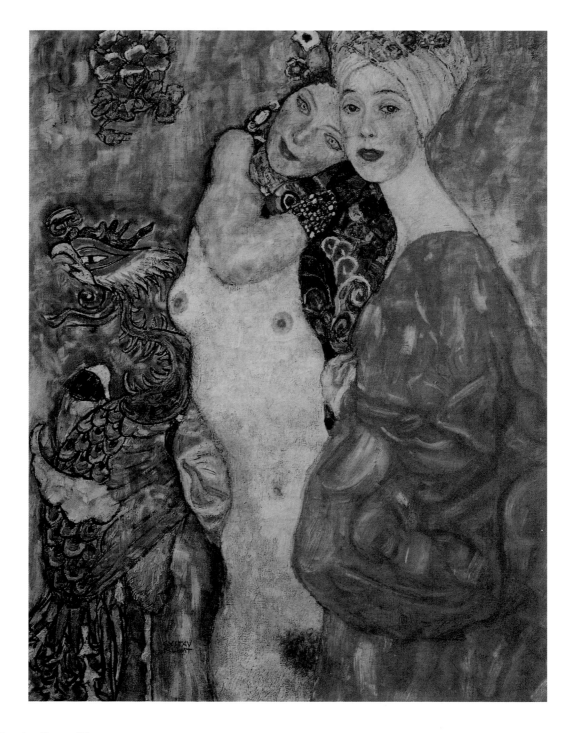

A fascination with women In *The Friends*, subtle red tones intensify the passion and intimacy of the scene. Despite the exoticism and frank sensuality they exude, the two women also seem reserved and self-contained, keeping their secrets to themselves. Voyeuristic glimpses into the private life of women fascinated Klimt all his life.

Love

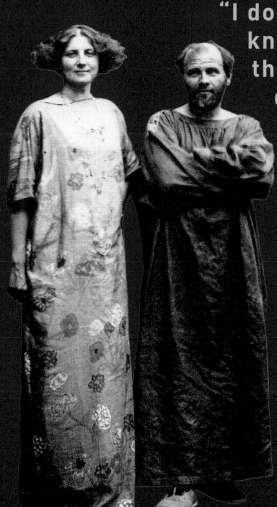

"I don't exactly
know myself how
things stand, and
don't want to know.
All I know is I'm a
poor fool. Because
I fear and respect
real love."

Gustav Klimt

Numerous affairs ...

... with a wide range of women were a feature of Klimt's life. But he never married. He had children with two of his models – children he willingly acknowledged – but his affairs with society women tended to be secret. The most important woman in his life was Emilie Flöge, with whom he had a close, confidential relationship that probably remained platonic, for reasons of delicacy.

Artist's muse

An extraordinary woman with whom Klimt had a brief fling involving both love and desire was Alma Schindler (1879–1964). Her father Jacob Schindler was a well-known and highly regarded Viennese painter, her mother, Anna, a singer who gave up her career to marry. The family was part of the prosperous artistic class and lived in great style. When Alma was thirteen, her father died, and her mother married the artist Carl Moll. From her earliest youth Alma was interested in art and literature – she knew the works of Wagner by heart, read Goethe, dabbled in sculpture, studied Nietzsche and was fond of the theater. But her main love was music, and she herself composed. All her life, Alma sought love among artists. The list of her lovers and husbands reads like a *Who's Who?* of the contemporary cultural scene: composers Alexander von Zemlinsky and Gustav Mahler, painter Oskar Kokoschka, architect Walter Gropius, and writer Franz Werfel, to mention just a few.

Women ...

-→ dominated Klimt's life in a variety of ways. After the death of his father and brother, he lived with his mother and sisters for the rest of his life.

-→ were his inspiration. The vast majority of his portraits are of women.

-→ wanted Klimt's love all for themselves. Both Adele Bloch-Bauer and Emilie Flöge insisted they were the female figure in *The Kiss*.

Free love ...

... as advocated by various artists in the early 20th century also seems to have been Klimt's preferred lifestyle. Living together without a marriage certificate – as practiced by Kandinsky and Gabriele Münter, and by Franz Marc and Maria Franck (members of the Munich art scene and the Blauer Reiter art group) – with each partner working on an equal basis, had its counterpart in the relationship between Klimt and Flöge.

A very special friend

Emilie Flöge, youngest daughter of Hermann Flöge, a manufacturer of meerschaum pipes, and his wife Barbara, was twelve years younger than Gustav Klimt, and the center of his social relationships. The two of them became acquainted in 1891, when Gustav's brother Ernst married Emilie's sister, Helene. Emilie and Gustav were closely involved in each other's lives. Over the years, Klimt sent her hundreds of postcards and also some letters, the contents of which indicate great affection and closeness. But even though their relationship was far more than mere friendship, it seems unlikely that they were ever lovers.

Femme fatales...

... was a term that became popular around the turn of the century to describe women who are both beautiful and dangerous, who seduce through their charm, sexuality or force of personality. *Femmes fatales* instilled fear in men but also captivated them, and this is a type found in Klimt's pictures. *Femmes fatales* appear in art (notably the paintings of the French artist Gustave Moreau) and in a great deal in contemporary literature.

Klimt's models

Klimt was by no means self-denying, however. Along with social pleasures such as drinking with friends in a café or playing tenpins, he greatly enjoyed the pleasures of the flesh, though they hardly ever involved emotional obligations or consequences, at least for him. He had sexual relationships with several of his models, many of whom spent a lot of time in his studio. Klimt paid his models liberally – no doubt for a wide range of services – and took financial responsibility for the children that came from the relationships. Mizzi Zimmermann had two sons by him, Maria Ucicka one. Klimt did not take such relationships seriously, but he handled his long-term affairs well.

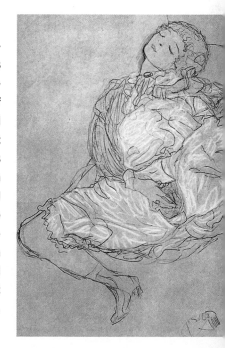

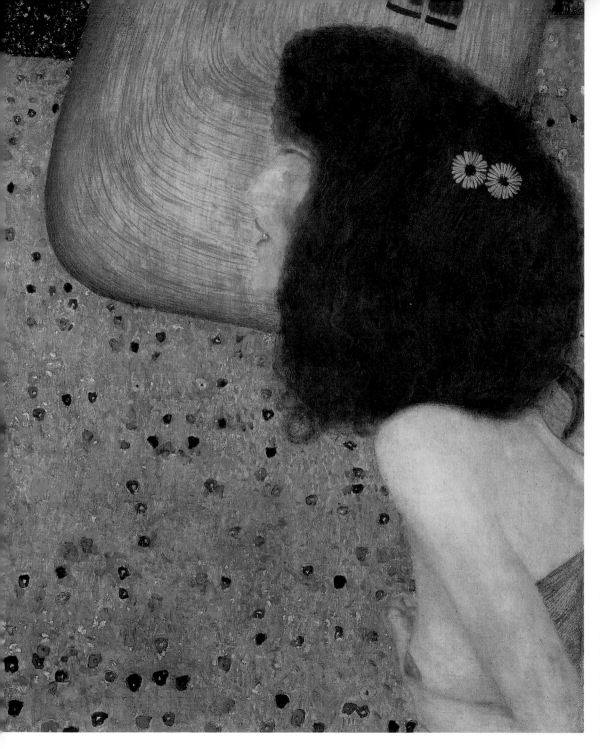

A great many women posed for Klimt, from professional models to society ladies. The identity of the young woman in this painting, *Girl with Blue Veil*, is not known.

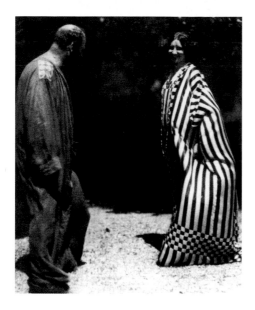

Klimt and Emilie Flöge dancing. Partners, friends or lovers? The exact nature of their relationship is still a mystery.

"Women are my chief work."

Klimt's life was bound up with women in every way. He painted them again and again in his pictures, and his mother and sisters took care of his home life. Society ladies easily succumbed to his charm and charisma, while his models not only posed for him but also became his lovers. Women fell for Klimt, and he seems to have been addicted to them.

Lifelong bachelor

It is known the Klimt had absolutely no ambitions as a writer – putting anything down on paper was a chore. Nor was he a man of words. We look in vain for hot-blooded love letters or outpourings of passion by him. He always endeavored to keep his private life and love affairs under lock and key, and never celebrated his relationships in public. Klimt seems to have had a strong sex drive and considerable sex appeal for women, as numerous erotic sketches and drawings show only too graphically.

But Klimt was a bachelor through and through, to the point of being the stereotypical 'eternal son,' for he lived with his mother and sisters all his life and happily let them look

> **"I'm less interested in myself as the subject of a picture than in other people, especially women."**
>
> **Gustav Klimt**

The Flöge sisters' fashion salon was furnished with all the modern trimmings. The design and execution of the interior furnishings were in the hands of the Wiener Werkstätte (Vienna Workshop).

after him. But in other respects he led a very private life of his own, living as he pleased. The possibility of marriage and family seems not to have arisen. Whether that was due to a rejection of middle-class relationships, or to an unwillingness to give up his comfortable existence, is an open question. As is the matter of whether there was ever a 'great love' in his life, with passion, jealousy, sleepless nights, and whispered vows. For him, women were possibly not important enough as partners in the real world. Perhaps he wanted to see them only as unfathomable muses. Or perhaps he was not even capable of passionate love. The only woman who outlasted all his affairs, had a real share in his life, appeared in public with him, and knew every detail of his daily life – in part because of the hundreds of postcards he sent her – was Emilie Flöge. She was his closest confidante to the day he died.

An independent woman

Emilie Flöge, who also remained unmarried all her life, occupied a very special position in Klimt's life. Her energies were devoted to the Flöge Fashion Salon, which she started with her sisters Pauline and Helene in 1904. Pauline had earlier already founded a school for dressmaking, and that was where Emilie and Helene began their careers, soon becoming independent dressmaking. In 1899 they had won a major commission – the designs they sent in were selected for uniform for a cuisine exhibition. Soon they had earned enough money to open their fashion salon in Vienna's modish Mariahilferstrasse, where the sisters lived and worked with their mother. By 1932, when the salon was forced to close under pressure from the Nazis, the business had twenty-seven employees.

Emilie and Gustav met probably met in 1891, which was the year Gustav's brother Ernst married Helene Flöge. Scarcely a year later Ernst died, leaving Gustav as the guardian of his sister-in-law and his niece, and so

During a summer stay beside the Attersee, Klimt photographed Emilie in clothes they had designed jointly. In this picture, Emilie wears a chain with a heart-shaped pendant Klimt had had made for her.

On 8 July 1908, Klimt sent this card with his 'very warmest' greetings to his 'Midi' (Emilie Flöge), who was already on vacation at the Villa Oleander.

financially responsible for them. Emilie remained financially independent and she had her life completely under control. She regularly traveled to Paris and London to see the latest creations in the fashion world. And every year she went with Gustav on their summer vacation, or waited for him there, as generally she was able to leave the city sooner than he could. She took great care of her health, and had time off to take the waters several times a year, fearing respiratory diseases. At home in Vienna, she often looked after Klimt's business affairs, dealing with his correspondence, or phoning on his behalf because he hated it so much. So she was there for him when he needed her, but led a life of her own that was mostly taken up by work. The question arises whether Emilie Flöge was, as she is often represented, a martyr for Klimt, forever awaiting a proposal from him, ultimately in vain.

Love or friendship?

When Klimt met Emilie, she was seventeen. He immediately did a portrait of her (page 71) in the first year of their acquaintance, but at that date there was nothing to suggest a love affair – Gustav urgently needed models, and Emilie was a pretty, fine-boned girl, and moreover one of the family. The latter was the critical factor for their budding friendship. As their being together breached no rules of social behavior, they could see each other without provoking undue speculation or gossip. Klimt and Emilie began to send each other brief messages several times a day. For example, Klimt would sometimes ask if he could drop in for a glass of schnapps sometime after nine; a few years later he did not even ask permission, but went straight in when he wanted to visit her, knowing he would be welcome. On official occasions such as the art show in 1908, Emilie was at Gustav's side, and they would visit mutual friends together at a resort on the Attersee. Their social circles were intertwined in other ways as well – Josef Hoffmann and Koloman Moser designed

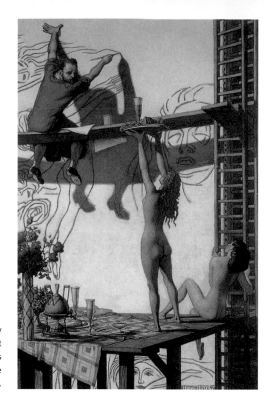

This image of Klimt was painted by Remigius Geyling in *c.* 1902. Klimt is shown transferring his cartoons of *Philosophy* to the wall, with the assistance of two nude helpers.

the interior of the Flöge sisters' fashion salon, and Klimt commissioned jewelry for Emilie from both men, which she loved and wore frequently. Emilie and Gustav took French lessons together, Emilie helped Gustav in the production of cartoons for the *Stoclet Frieze*, and Gustav encouraged Emilie to design new Reform-style fashions. And yet all the clues that have been zealously presented as evidence of love between Emilie and Gustav are in no way conclusive. There are no photographs of them embracing, no self-indulgent love letters, and no acquaintances who had anything to report by way of supposition or direct evidence. In fact, the contrary is the case. In the view of a distant friend from their summer holidays, that would have been inconceivable. "Those two a couple? Never!" But she immediately added, ambiguously: "That is the only explanation for her lifelong hyper-nervousness."

The enigma of Emilie

Emilie has always been considered the selfless and devoted woman who looked after all Klimt's interests and yet left him total freedom. But Emilie also had her work, a salon that was doing well and supplied fashions to Vienna's society women. If she had married Klimt, she would probably have had to give up her career. In that light, the relationship looks very different. Klimt's postcards frequently voice the complaint that Emilie does not write in enough detail, or often enough, or had left for Paris too soon. When he himself traveled to Spain and France, he sent her letters expressing a wish for her to meet him at the station, saying that he was looking "royally" forward to it, and called her "my dear silly little Midelin, my Midessa!" He told her he dreamt of her. Moreover, Klimt gave his Midi a specially made brooch shaped like *The Kiss*, with *Gustav* and *Emilie* written on it. So was it love after all? If it was, why the secrecy? That Klimt probably never spent the night with Emilie is clear from a wealth of letters. And in this regard a dark issue common at the time needs to be considered: Klimt had probably become infected with syphilis, and perhaps did not want to infect Emilie. Yet with other women – most frequently his models – he

Alma Schindler *c.* 1900, the wife, friend and lover of numerous artists, writers and composers. Klimt was her first love.

was undoubtedly intimate. Emilie must have known about them, and the children they had by him. Did it break her heart? Or was she glad not to have been forced into the role of wife and mother? Did she have another lover? We do not know. But that Klimt wanted to have her near him until the very last, and that she took care of his estate when he died, tells a poignant story.

Toying with others' feelings

Klimt had no objections to amorous adventures and affairs. Alma Schindler (the later Alma Mahler), for whom Klimt was her first love, complained bitterly of the notorious philanderer that he "associated with worthless women," by which she meant his models. In the same year that the two began their romance, Klimt also had an affair with Adele Bloch-Bauer. Not only the infidelity tormented Alma – it was also the idea that his various commitments prevented him from accepting the responsibility of a single real relationship. "He had ties in a hundred places – women, children and sisters who out of love for him were enemies to each other." And she

accused him of deliberately arranging it that way: "He toyed with others' feelings as a matter of habit."

Alma no doubt had a sour view of Klimt because he rejected her love for him and backed out of their involvement in a rather underhand and cynical way. The much-fêted young Alma had initially aroused Gustav's interest, and he began to woo her, to the point where, despite his dislike of travel, he went with Alma and her parents Anna and Carl Moll to Italy, where as far as possible the two of them were kept apart. Nonetheless, they met secretly, and a kiss was given and taken. Alma entrusted her secret to her diary, which came into her mother's hands and was read. The parents issued threats and insisted that the flirtation had to stop. But Alma was hopelessly in love: "Gustav Klimt came into my life as my first great love, but I was an innocent child, immersed in music and ignorant about life. The more I suffered from this love, the more I became absorbed in my own music, so that my unhappiness became the source of my greatest bliss." She was willing to swear eternal fidelity to him. But Klimt, more concerned about

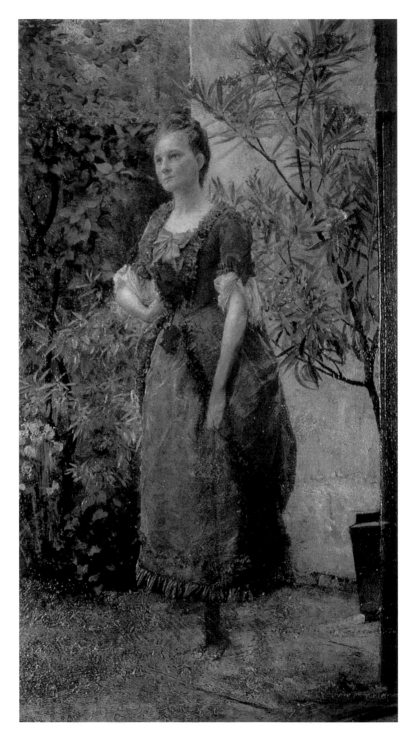

Garden backdrop Klimt's second portrait of Emilie Flöge was a study for a history painting in Klimt's early period. She wears period clothes and stands beside a blooming oleander bush. It is assumed that Emilie posed for the picture in his studio in Josefstädterstrasse, where there was such an overgrown garden.

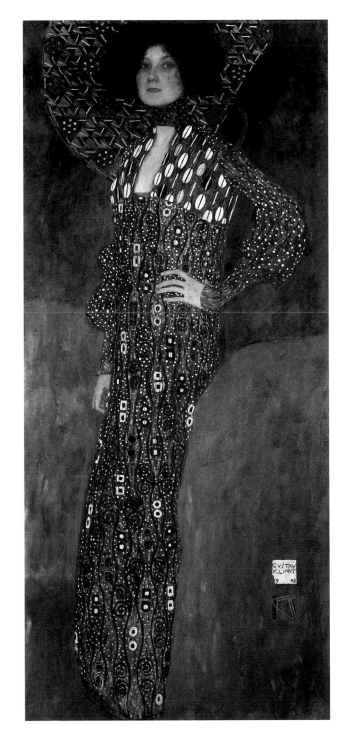

Midi's picture Klimt painted several portraits of Emilie, this one of 1902 being the last. It is often said Emilie did not like the picture. When Klimt sold it, he wrote to his 'Midi' that he had been scolded by 'Mother' – it is not clear whether his or hers – and told to do a replacement as soon as possible. He never did.

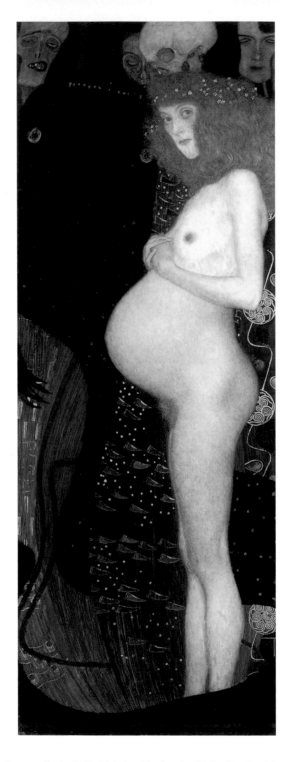

Hope The representation of pregnant women had got Klimt into trouble already with the 'faculty pictures.' This allegory of *Hope*, however, was not a commission, so he could do what he liked. Interestingly, he combines imminent motherhood with attributes of *femmes fatales* (red hair, long slender legs, direct gaze).

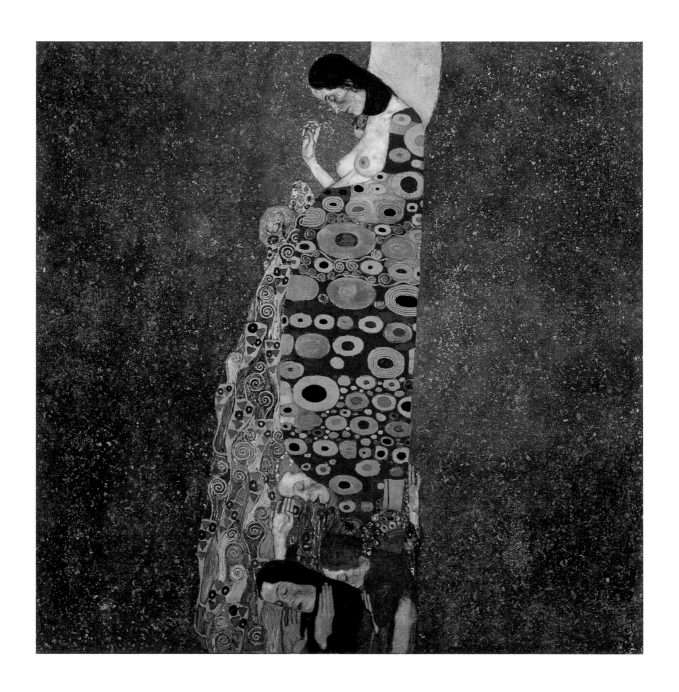

Burgeoning life *Hope II*, done four years after the first version (opposite page), is a much-compressed symbol for the cycle of life. The pregnant woman gazes pensively at her shrouded belly. The threatening-looking faces and skull of the first version have gone.

Otto was Klimt's and Mizzi Zimmermann's second-born son, but he lived only two years. Klimt drew his dead son in 1903.

a good relationship with his friend Carl Moll, called off their budding relationship and wrote to Moll – Moll, not Alma! – a letter attempting to wriggle out of it. "In your paternal concern, you see things more bleakly than they are! I've never paid court in the real sense of the word ... from a few leading questions and probing remarks it seemed to me that things were not as wholly indifferent to the young lady as I had initially supposed. Thereupon I became rather alarmed ... I came in conflict with myself, and in conflict with my true feeling of friendship for you. But I consoled myself with the thought that it is all just fooling around on her part, a whim. Alma is beautiful, intelligent, witty, she has everything a discriminating man can ask of a woman ... Then came that evening in Venice. I'm an embittered man, and that sometimes finds expression in a not wholly innocent malice that I subsequently regret profoundly. So there too ... Forgive me, dear Moll, if I am causing you any anxiety. I ask your good wife's and Miss Alma's pardon. I don't think it will be difficult for her to forget."

Available women

In this letter to Carl Moll, Klimt reveals the true nature of his relationships with women: as a 'discriminating man,' he expects his playmate to fulfill very high expectations. And as a successful artist, relatively prosperous and sought after, it was a matter of course that his expectations should be fulfilled – if not in *one* woman, then in several. Woman was his *chef d'oeuvre*, and he was constantly trying to fathom her mysterious and compelling being – on canvas.

In real life, he could afford to satisfy all his tastes and inclinations. There were for example models such as Mizzi Zimmermann, who was financially dependent on him and even had his children. In the case of such a connection, given Klimt's social status, it was obvious what was involved: Klimt's sexual needs. Mizzi could hardly expect him to marry her; and yet she remained devoted to him. When she became pregnant, the subject of pregnancy appeared in Klimt's work. But he was probably fascinated by the familiar theme of the cycle of life, not by the prospect of being a father or having a family.

Klimt's pictures of pregnant women regularly shocked the public. In this sketch for *Hope II*, he drew his model naked, though in the final work she is covered (page 99).

the *Comedy of Seduction* on the subject, the hero being easily identifiable as Klimt: "There was always a model or two waiting in the lobby, so that sources of infinite variations on the theme of woman would continually be available to him." What kind of inspiration that could sometimes be, Klimt recorded in his erotic drawings, some of which were published only after his death. They included lesbian lovemaking, women masturbating, and of course sex between men and women.

Forbidden fruit

Did Klimt see and paint women only as objects of desire? Or did he give them a will of their own, showing them strong and combative, as for example in *Pallas Athene*? Or bringing destruction, as in *Judith*? Many of his paintings certainly make his women 'available,' free for the public to inspect and observe in intimate situations. In the case of the models, it could do them little harm because they did not (according to the morality of the period) have a reputation to lose. When it involved women from the upper classes, who could be

In Vienna, Klimt's sexual openness was of general public interest, and aroused a lascivious fascination. At a time when women's sexual feelings were not publicly recognized, the public relished tales of Klimt's adventures. As 'an artist,' Klimt was not obliged to feel constrained by social morality. Arthur Schnitzler wrote

A sketch for *Judith I*, for which Adele Bloch-Bauer was almost certainly his model. The painting (page 104) was taken as evidence of an affair between them, and set the scandalmongers gossiping.

here again, there is no report of tragic, desperate love. We can only work from assumptions that to some extent derive from Klimt's paintings. The same applied Rose von Rosthorn-Friedmann, whose portrait he painted (pages 36 and 37).

Who's being kissed?

In his paintings, which contain personal as well as allegorical content, Klimt could 'ennoble' his women in paint, turning them into innocent, unconsciously erotic figures from a fairy-tale. Or he might turn them into sinister, dangerous creatures from other worlds, or simply strip them, making their physical nakedness public. Klimt covered his women with sexual symbols – with sperm-like threads, vulva-shaped ovals, or circles as female symbols, and corners, lines or pillars as male or phallic symbols. There's a lot of room for guesswork here. When he painted Adele Bloch-Bauer for the last time, did he paint her so sexless because he no longer desired her, or because he respected her social status as a married woman? Klimt never allowed a word on the

recognized in his pictures, that was a different matter. Adele Bloch-Bauer, the wife of a very rich sugar manufacturer, is probably represented in both Judith pictures, so they are monuments to her. Relationships with women like Adele were entirely of mutual benefit. For Gustav, it was exciting to be intimate with an intelligent, rich and cultivated woman, while for the women it offered an opportunity to be more closely involved in the art scene, to come into intimate contact with a fascinating artistic temperament. It was very flattering to be the 'muse' of a painter of genius. But

The models Klimt drew in his erotic sketches remain anonymous. His concern was not with portraiture, but with recording physical abandon.

subject to reach the public. He also never asserted that the painting *The Kiss* represented his personal notion of fulfilled love, with the woman he most wanted as a partner. Both Emilie and Adele later claimed to have been the model for the female figure in this celebrated work. The painting is of course in the first place a symbol for all men and women who love each other with overwhelming and all-consuming intensity. The man bending over the girl in *The Kiss* is certainly reminiscent, like most of the men Klimt painted, of the artist himself, with the characteristic bull-like neck and full-length gown. Possibly Klimt was painting himself in the way he desired his own fulfillment through love – with an ideal rather than a real partner.

The one and the many

In his paintings, Klimt looked for ideal love again and again. But perhaps the ideal came close to the reality that he lived. He could live as he wished, without accepting obligations (except financial ones, which seem not to have worried him). He moved easily between the social classes – he himself was born of a humble family but through his paintings made it to high society. By seducing women of the establishment, he boosted his ego. But he also found and loved a strong, intelligent, self-assured, creative, and self-reliant woman who left him his freedoms and protected her own – Emilie Flöge. Emilie and Gustav adopted the position that was probably best for both of them, and it was a progressive attitude for their day.

When in 1918 Klimt had a stroke from which he would not recover, he emphatically wanted one thing: "Get Midi!" He knew she would come at his bidding, and she did. She hurried to his side and cared for him until he died. She was his executor, and his estate was divided between her and his family. She is supposed to have burnt a large part of the correspondence at the time. Emilie preserved the memory of Gustav for the rest of her life, until her own death in 1952.

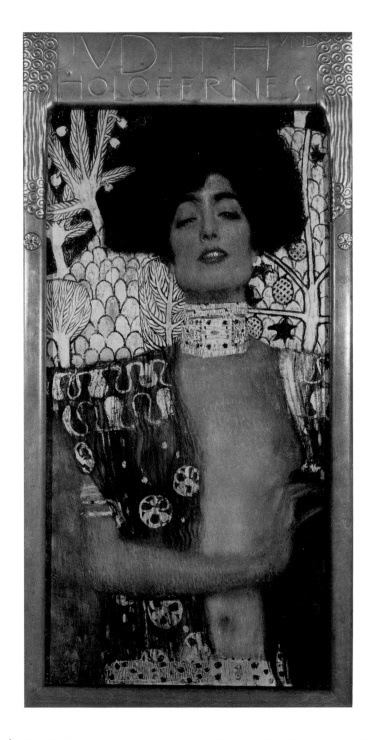

Beautiful, haughty, dangerous A Viennese *femme fatale*. Around 1899, Adele Bloch-Bauer was the sitter for the biblical figure of *Judith*. It is not officially a portrait, but she can be identified from the jewel-studded neckband, a present to his wife from the rich sugar manufacturer Ferdinand Bloch-Bauer.

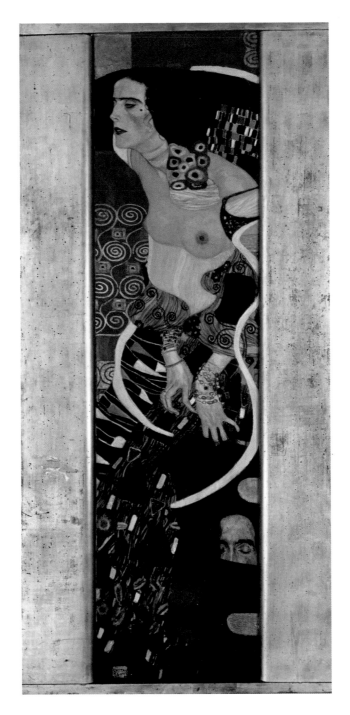

Unfathomable Eight years after the Gold Period masterpiece (opposite page), Klimt painted another *Judith*, and again it seems to have been Adele Bloch-Bauer he was painting. The work is occasionally called *Salome*, because the female figure appears to be in the ecstasy of dance. *Judith II* looks unscrupulous and bloodthirsty, unfathomable, and strangely excited by the killing of Holofernes, whose severed head appears at the bottom of the picture.

Mysterious attraction Delicate will-o'-the-wisps gleam mysteriously in this picture of 1903. The fluid lines growing into wavy hair, alluring female faces, and a seductively gleaming body are what create the mood of this picture.

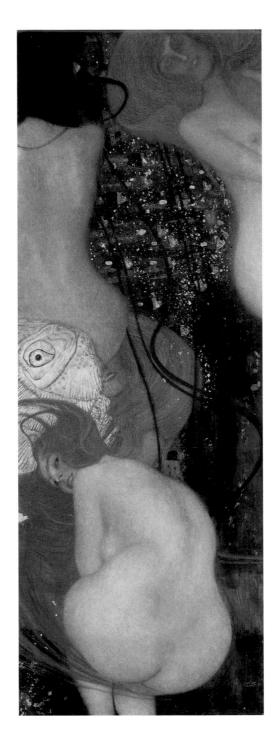

Getting his own back Originally Klimt called this picture *To My Critics* – it was his response to the angry rejection of the 'faculty pictures.' The impudent backward look of the red-haired woman and unmistakable intent of her posterior were too much. On his friends' advice, Klimt renamed the work *Goldfish*. But the point was made!

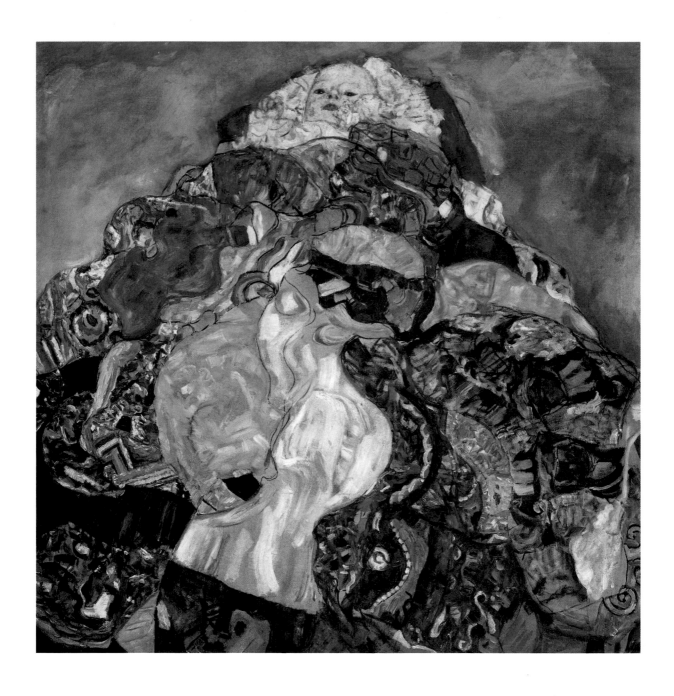

The fount of life This unfinished work of 1917/18 shows a baby in a cradle – life beginning. Is the infant on top of a mountain, from which point it can only go downhill? Or is the birth of a child the joyful highpoint of the cycle of life?

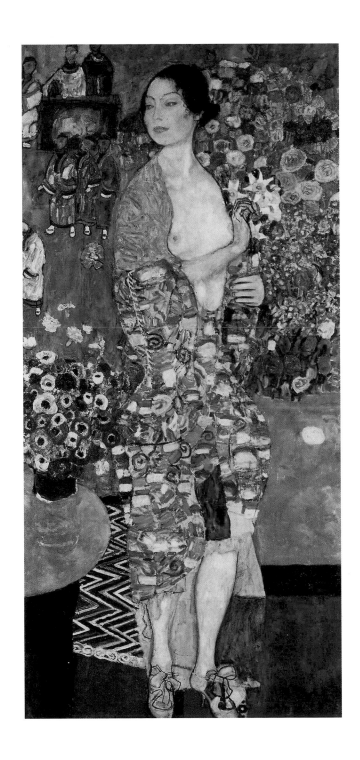

Dancer Klimt's fascination with erotic depictions continued into his colorful late period. As so often in Klimt's paintings, the rich patterns of the dancer's dress relate her closely to the background. The Asiatic figures on the left derive from Klimt's enthusiasm for Far Eastern art.

Klimt Today

"I have endeavored
to present the figure
of Klimt in the way
Arthur Schnitzler
told stories."

Raoúl Ruiz commenting on his
film *Klimt*, with John Malkovich
as Gustav Klimt (right).

Vienna's famous son ...

... would be amazed to know that the world is more interested in his work now than ever before. He has become a symbol of Austrian art and culture, and of the Art Nouveau style. The works that caused such controversy in their time have become part of everyday life, while the originals fetch breath-taking prices in the art market. But anyone looking for Klimt will still find him mainly in his native city.

An Austrian café in New York

The Neue Galerie in New York is dedicated to the preservation of German and Austrian art from the early 20th century. Masterpieces from Gustav Klimt, Egon Schiele and Oskar Kokoschka as well as works from their German contemporaries Paul Klee, Franz Marc and Wassily Kandinsky have made this museum a visitor's magnet ever since its opening in 2001 (see page 120 as well). Not only the collection is well worth a visit but also the museum's café 'Sabarsky' – named after one of the museum's founders – offers a charming place to relax. The interior, consisting of furniture designed by Adolf Loos, upholstery designs by Otto Wagner and lamps by Josef Hoffmann along with a menu full of Austria specialties like strudel or linzertorte, creates a café atmosphere reminiscent of Klimt's era.

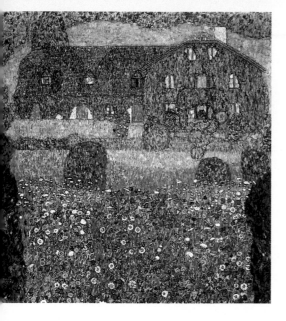

Landscapes

Painter of sensual women, master of Viennese Art Nouveau, a famous society portrait painter – those are the phrases typically used when Klimt is discussed. His landscapes are known far less, in fact virtually ignored. It was not until 2002, when the Oesterreichische Galerie at the Belvedere in Vienna put on an exhibition devoted exclusively to Klimt landscapes from European and American museums and private collections, that that this aspect of his work received due appreciation. The exhibition was a great success, with over 100,000 visitors passing through the turnstiles to see his landscapes, which are remarkable for their brilliant colors and highly original compositions.

Any advance?

A key work at the great exhibition of landscapes was the *Country House on the Attersee* (left), which was sold at Sotheby's in New York for over $29 million in November 2003. In 2006 his *Portrait of Adele Bloch-Bauer I* (page 42) sold for a staggering $135 million, to the cosmetics millionaire Ronald S. Lauder.

Klimt for all

Because his subject matter continues to enjoy popularity, a vast number of 'fan articles' are available. Anyone who can't do without Klimt under any circumstances can buy Klimt ties, key rings, pottery, reproductions, postcards, or even puzzles. You can even get Klimt-style skiwear. Would this keen trade in art and utility objects have pleased the Secessionists? Undoubtedly it would have elicited an ironic smile from the fun-minded among them. You can even spend your vacations with Klimt – many travel companies have specialized in 'Klimt-experience' trips to the Attersee, where visitors can follow the trail of the painter's summer holiday spots and visit the places he enjoyed painting.

His last studio

Something not to be missed on your next visit to Vienna is Klimt's studio, documented in numerous photographs, with the artist standing there in the garden, walking down the path or holding one

of his cats. His studio has now been largely reconstructed. The Gedenkestätte Gustav Klimt is the body that looks after the house and is restoring it to its original condition. The studio brings the painter's story alive. Located at Feldmühlgasse 15a, in Vienna's 13th district, it is only a few minutes' walk from Unter St Veit subway station.

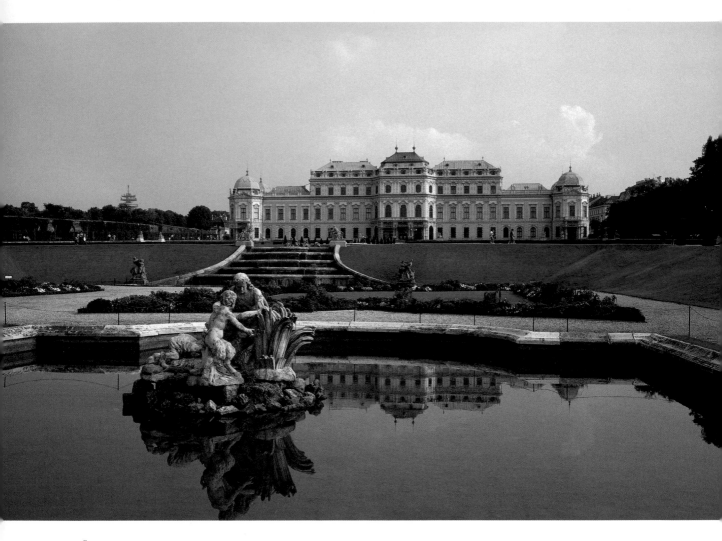

The Österreichische Galerie at the Belvedere in
Vienna has one of the most important collections
of Klimts.

Klimt's *Avenue at Schloss Kammer* is one of the highlights of the Belvedere's collection

Klimt's world

Klimt was not one of those artists who enjoy public esteem only after they are dead. In his own day he was a celebrated public figure, and his works were appreciated by art collectors and museums. His role in the history of art is also firmly established. But he probably would never have dreamed that he would be so widely know around the world.

Art Nouveau boom

In *fin-de-siècle* Vienna, Klimt's works, like those of Schiele or Kokoschka later, regularly provided grist for the scandal mill. Too much nudity, too much sex, too much for decent society to accept. Today's viewer is far less likely to be outraged by the sight of a naked, pregnant woman. Since the sexual liberation of the 1960s, nakedness hardly causes a comment, and same-gender sex is no longer taboo. In fact, Klimt's art in today's climate tends to look more romantically elegant than offensive. Interest in the works of the more fanciful reaches of Art Nouveau revived in the late 1980s, when chrome, glass and synthetic music

> **"I've tried to make a film the way Klimt himself would have made it."**
>
> **Raoúl Ruiz**

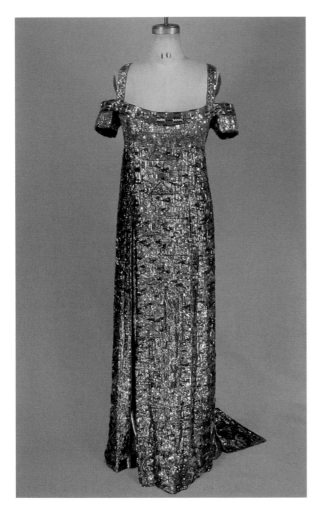

In 1984, Barbara Streisand got fashion designer Ray Aghayan to make her a very special dress, based on the one worn in Klimt's *Portrait of Adele Bloch-Bauer* (detail below).

dominated modern aesthetics. Did people suddenly hanker after the refinement of that period? Or did the imminent final rites for the 20th century produce a similar apocalyptic mood as that of the *fin-de-siècle*? At any rate, prices of Art Nouveau works in general and Klimt's pictures in particular shot up towards the end of the decades of prosperity.

Klimt in Paris and Vienna

A Klimt is nowadays a priceless asset – and film stars such as Sharon Stone are aware of it. During a visit to the *Vienna 1900* exhibition at the Galeries Nationales du Grand Palais in Paris in 2005/06, which featured Klimt, Schiele, Moser and Kokoschka, Sharon Stone revealed that she already possessed a Schiele. Unfortunately, she added, she did not have enough "small change" for a Klimt – prices were soaring to astronomical levels at the time. The exhibition in Paris was, incidentally, the biggest ever accorded to Viennese artists.

A great admirer
of Gustav Klimt –
actress Sharon
Stone.

Back in Vienna, Klimt is an ever more popular export success. His works are reproduced and distributed in vast numbers. The famous pictures *The Kiss*, the golden *Portrait of Adele Bloch-Bauer I* (now as well know for its value as for its subject or style), or the sexually charged *Judith* brighten up walls in all sorts of improbable places around the world. Klimt has become a classic.

Klimt as inspiration

Among those who valued Klimt was the modern Austrian artist Friedensreich Hundertwasser (1928–2000). His ornamental style full of elegant curves can be traced directly to Klimt's pictures, as Hundertwasser himself often observed. Fashion designers were likewise similarly inspired – the collections of Christian Dior, Chanel, and Yves Saint Laurent display echoes of the *fin-de-siècle* flair. Barbra Streisand, who confessed she was a great fan of the *Portrait of Adele Bloch-Bauer*, got designer Ray Aghayan to produce his own version of the dress that Adele wears in the picture. She put on the resulting 'golden dream' to be presented with the

Scopus Laureate Award in 1984. This unique dress was later auctioned in 2004 for $5,760, and in 2006 went on sale for well over $20,000.

Hollywood in Europe

Any number of opulent and probably not exactly cheap costumes, hats and sumptuous outfits can also be admired in Raoúl Ruiz's sumptuous film *Klimt*, premiered in 2006. It was the fulfillment of a long-standing dream for the director, who also wrote the screenplay. Far from being a faithful representation of Klimt's life, Ruiz's vision is a feverish dream, unfolding to an accompaniment of Ravel's *La Valse*. Ruiz sums up the film in two words – "frenzy" and "pleasure." Four countries – Germany, Austria, France and Britain – took part in the production. Klimt is played by John Malkovich, Emilie by Veronica Ferres, and Egon Schiele

Raoúl Ruiz on the set of his film *Klimt*.

Franco-Chilean director Raoúl Ruiz has won numerous awards.

by Nikolai Kinski, son of actor Klaus Kinski. Shooting took place at original locations in Germany and Austria, and Ruiz, who is a Klimt devotee, took every detail seriously. It is not artificial snow drifting from the ceiling in one scene, it's pure gold leaf!

A career in film

Born in 1899, Klimt's eldest son, Gustav, named after his father, was also a film director. He and his mother, Klimt's model, domestic help and mistress, Maria Ucicky were publicly acknowledged by the painter. But the son

John Malkovich as Klimt painting *The Friends* (page 85).

rejected this father's illustrious name in favor of his mother's maiden name, and from 1920 Gustav Ucicky worked in Austria, Spain, and Germany, first as a cameraman, and later as a director. During the Nazi years, he worked for the nationalistic film company UFA under Alfred Hugenberg. After the war, he made comedies and films of local interest. He died in Hamburg in 1961.

Klimt in Vienna

Where better to enjoy Klimt's work than in Vienna? It was his native city, he was devoted to it, and it now takes scrupulous care of his legacy. There is, for example, the

Beethoven Frieze to be admired at the Secession Building. And along with Klimt's works, the Secession Building also puts on exhibitions of young artists – the Vereinigung bildender Künstlerinnen is still involved in current developments in Austrian and international art. Another must-see is the Österreichische Galerie at the Belvedere. *The Kiss* and other Klimt works are on display here alongside works by Schiele, Kokoschka, Van Gogh, and Edvard Munch. The Belvedere was constructed by Prince Eugene of Savoy as a summer residence consisting of two blocks – the Upper and Lower Belvederes (pages 114 and 115) – with a elegant Baroque garden linking them. From the northern front of the Upper Belvedere there is a splendid view across a remarkable city, the city of Gustav Klimt.

Neue Galerie The businessman, patron, and art collector Ronald S. Lauder realized, after the death of his old friend, the art dealer Serge Sabarsky, their collective vision for a museum specializing in German and Austrian art from the early 20th century. The Neue Galerie, located on Fifth Avenue in New York, displays not only the masterpieces of Gustav Klimt and his companions, but also provides insight into the works of the artists of the Blue Rider and Die Brücke as well as from the New Objectivity and Bauhaus movements.

Change of ownership In 2006, after long negotiations, five Klimt paintings once owned by Adele Bloch-Bauer were awarded to her niece, Maria Altman (above). These works – one being the famous *Portrait Adele Bloch-Bauer I* - were taken from Adele's widower, Ferdinand Bloch-Bauer, in 1938 and placed in the collection of the Österreichischen Galerie Belvedere. After the paintings restitution, the 'golden Adele' was sold to Ronald S. Lauder for a record amount and now hangs in the Neue Galerie in New York.

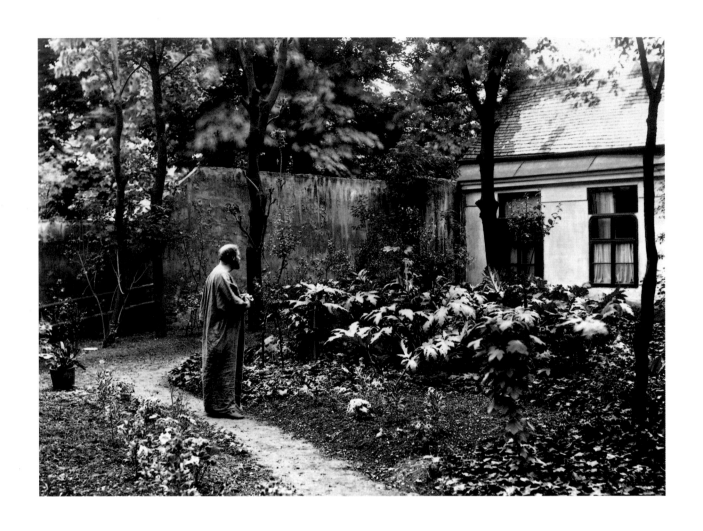

As it was Klimt standing in the garden of his last studio. The proximity of nature made the studio an ideal place for the artist to withdraw to, and it became his second home.

As it is now The studio has undergone rebuilding, and is now run by the Verein Gedenkstätte Gustav Klimt. It is planned to make the place accessible to Klimt pilgrims and keep the artist's legacy alive with a wide spectrum of cultural activities.

Picture list

p. 1: Gustav Klimt, *Fulfillment* (detail), cartoon for the *Stoclet Frieze*, c. 1905–1909, tempera, watercolor, gold paint, silver bronze, crayon, pencil, opaque white, gold leaf, silver leaf on paper, 194 x 121 cm, Österreichisches Museum für angewandte Kunst, Vienna.

p. 5: Countess Draskovich out walking in Vienna with Ferdinand, Prince Auersperg. He is wearing the uniform of a guards officer. Photograph c. 1912.

p. 6: Bertold Löffler, poster for the Fledermaus cabaret, 1908, lithograph, Wien Museum, Vienna.

p. 7 top left: Cotton dress designed by Koloman Moser, 1905.

p. 7 top right: Woman putting on a corset, photograph.

p. 7 bottom: Franz Xaver Winterhalter, *Empress Elisabeth*, 1865, oil on canvas, Hofburg, Vienna.

p. 8: View from the tower of the town hall towards the new Burgtheater and Old City, Vienna, c. 1890, photograph.

p. 9: Gustav Klimt, *Auditorium of the Old Burgtheater, Vienna*, 1888, gouache on paper, 82 x 92 cm, Wien Museum, Vienna.

p. 10: G. v. Kempf, *Electricity*, from *Allegorie und Embleme*, published 1882.

p. 11 left: Hermann Bahr, c. 1910, photograph.

p. 11 right: Arthur Schnitzler, photograph.

p. 12: Hans Makart, *Nile Hunt*, 1876, oil on canvas, 270 x 450 cm, Österreichische Galerie, Belvedere, Vienna.

p. 13: Gustav Klimt, *Fable*, 1883, oil on canvas, 84.5 x 117 cm, Wien Museum, Vienna.

p. 15: Gustav Klimt, *Nuda Veritas* (detail), 1899, oil on canvas, 252 x 56.2 cm, Bahr-Mildenburg estate, Österreichisches Theatermuseum.

p. 16: Gustav Klimt, *Philosophy* (detail), 1899–1907, oil on canvas, 430 x 300 cm, destroyed by fire in Schloss Immendorf in 1945.

p. 17 top: Vienna Secession Building, with Naschmarkt stalls in front, 1899, photograph by Bruno Reiffenstein.

p. 17 bottom: Ludwig von Zumbusch, cover of *Jugend*, no. 40, 1897.

p. 18: Joseph Maria Olbrich, Secession Building, Vienna, 1897/98.

p. 19: Interior view of the Vienna Secession Building with Klimt's *Beethoven Frieze*, and Max Klinger's Beethoven sculpture in the room beyond, 1902, photograph.

p. 20: Gustav Klimt, *Theater in Taormina* (detail), 1888, oil on plaster ground, 750 x 400 cm, Burgtheater, Vienna.

p. 21 left: Gustav Klimt, *Jurisprudence* (from the 'faculty pictures' series), 1903–1907, oil on canvas, 430 x 300 cm, destroyed by fire in Schloss Immendorf in 1945.

p. 21 right: Gustav Klimt, *Classical Greece II (Girl from Tanagra)*, 1890/91, oil on plaster ground, c. 230 x 80 cm, inter-columnar picture in the stairwell of the Kunsthistorisches Museum, Vienna.

p. 22: Gustav Klimt, poster of the first Secession exhibition, 1898, color lithograph, 97 x 70 cm, Wien Museum, Vienna.

p. 23 top: The opening of the Vienna Art Show in 1908, photograph.

p. 23 bottom: Volume 1 of *Ver Sacrum* in the original Secession cloth binding, 1898, Emma Teschner Collection, Österreichische Nationalbibliothek, Vienna.

p. 24: Gustav Klimt, *Death and Life*, 1916, oil on canvas, 178 x 198 cm, Leopold Museum, Vienna.

p. 25: Gustav Klimt, *Adam and Eve* (unfinished), 1917/18, oil on canvas, 173 x 60 cm, Österreichische Galerie, Belvedere, Vienna.

p. 26: Gustav Klimt, *Beethoven Frieze* (detail), 1902, casein color on plaster ground, 2.2 x 24 m, Österreichische Galerie, Belvedere, Vienna.

p. 27: Gustav Klimt, *Beethoven Frieze* (detail), 1902, casein color on plaster ground, 2.2 x 24 m, Österreichische Galerie, Belvedere, Vienna.

p. 29: Gustav Klimt, *Hygieia*, detail from *Medicine* (from the 'faculty picture' series), 1900–1907, oil on canvas, 430 x 300 cm, destroyed by fire in Schloss Immendorf in 1945.

p. 30: Hans Makart, *The Five Senses: Sight* (detail), 1872–1879, oil on canvas, 314 x 70 cm, Österreichische Galerie, Belvedere, Vienna.

p. 31 top: Arnold Böcklin, *Flora Waking the Flowers*, 1876, tempera on wood, 78 x 53 cm, Von der Heydt Museum, Wuppertal.

p. 31 bottom: Gustav Klimt, *Beethoven Frieze* (detail), 1902, casein color on plaster ground, 2.2 x 24 m, Österreichische Galerie, Belvedere, Vienna.

p. 32: Gustav Klimt, *The Virgin*, 1913, oil on canvas, 190 x 200 cm, Národní Galerie, Prague.

p. 33: Gustav Klimt, *Water Snakes II*, 1904–1907, oil on canvas, 80 x 145 cm, private collection.

p. 34: Gustav Klimt, study for *Sculpture*, from *Allegorien und Embleme, Neue Folge*, 1896, chalk, pencil on paper, 41.8 x 31.3 cm, Wien Museum, Vienna.

p. 35: Gustav Klimt, study for *Bride*, 1911/12, pencil and opaque white on paper, 37 x 56 cm, private collection.

p. 36: Gustav Klimt: *Portrait of Rose von Rosthorn-Friedmann*, 1900/01, oil on canvas, 190 x 120 cm, privately owned, Vienna.

p. 37 left: Gustav Klimt, *Water Nymphs (Silverfish)*, c. 1899, oil on canvas, 82 x 52 cm, Z-Länderbank Austria AG.

p. 37 right: Gustav Klimt, *Three Ages of Life*, 1905, oil on canvas, 180 x 180 cm, Galleria Nazionale d'Arte Moderna, Rome.

p. 38: Gustav Klimt, *Garden Path with Hens*, 1916, oil on canvas, 110 x 110 cm, destroyed by fire in Schloss Immendorf in 1945.

p. 39: Postcard from Gustav Klimt to Anna Klimt, 1902.

p. 40: Gustav Klimt, *Lady with Hat and Feather Boa*, 1909, oil on canvas, 69 x 55 cm, Österreichische Galerie, Belvedere, Vienna (returned to original owner's heirs in 2001).

p. 41: Gustav Klimt, *The Kiss*, 1907/08, oil on canvas, 180 x 180 cm, Österreichische Galerie, Belvedere, Vienna.

p. 42: Gustav Klimt, *Portrait of Adele Bloch-Bauer I*, 1907, oil and gold leaf on canvas, 138 x 138 cm, Neue Galerie, New York.

p. 43: Gustav Klimt, *Portrait of Adele Bloch-Bauer II*, 1912, oil on canvas, 190 x 120 cm, private collection.

p. 44: Gustav Klimt, *Unterach am Attersee (Houses beside Attersee)*, 1914, oil on canvas, 110 x 110 cm, Museum für Moderne und Zeitgenössische Kunst, Rupertinum, Salzburg.

p. 45: Gustav Klimt, *Church in Unterach am Attersee*, 1916, oil on canvas, 110 x 110 cm, private collection.

p. 47: Gustav Klimt beside the Attersee, *c.* 1910, Lumière autochrome plate by Friedrich Walker.

p. 48: Gustav Klimt and Emilie Flöge in a rowing boat, 1909, photograph.

p. 49 top: Gustav Klimt's studio, 1918, photograph.

p. 49 bottom: Gustav Klimt, *Forest Slope in Unterach am Attersee*, 1916, oil on canvas, 110 x 110 cm, private collection.

p. 50: Egon Schiele, *Gustav Klimt in his Blue Painting Smock*, *c.* 1912, pencil, opaque paint, 52.5 x 28 cm.

p. 51: Moritz Nähr, Gustav Klimt, *c.* 1910, photograph.

p. 52: Gustav Klimt's birthplace at Linzerstrasse 247, Vienna, *c.* 1900, photograph.

p. 53: College of Arts and Crafts, Vienna, *c.* 1900, photograph.

p. 54: Ferdinand Laufberger's class at the College of Arts and Crafts, *c.* 1880, photograph.

p. 55 top: Gustav Klimt, *Two Girls with Oleander*, 1890–1892, oil on canvas, 55 x 128.5 cm, Wadsworth Atheneum, Hartford/Connecticut.

p. 55 bottom: photographic study for *Shakespeare's Theater*.

p. 56 left: Gustav Klimt's apartment, photograph.

p. 56 right: Julius Zimpel, *Klimt's Room*, watercolor.

p. 57: Gustav Klimt, *Portrait of Helene Klimt*, 1898, oil on card, 60 x 40 cm, private collection.

p. 58: Gustav Klimt, *Portrait of a Lady*, *c.* 1894, oil on wood, 39 x 23 cm, Wien Museum, Vienna.

p. 59: Gustav Klimt, *Portrait of Serena Lederer*, 1899, oil on canvas, 188 x 83 cm, Metropolitan Museum of Art, New York.

p. 60: Gustav Klimt, *Portrait of Pianist and Piano Teacher Joseph Pembauer*, 1890, oil on canvas, 69 x 55 cm, Tiroler Landesmuseum Ferdinandeum, Innsbruck.

p. 61: Gustav Klimt, *Portrait of Fritza Riedler*, 1906, oil on canvas, 153 x 133 cm, Österreichische Galerie, Belvedere, Vienna.

p. 62: Gustav Klimt, *Nuda Veritas*, 1899, oil on canvas, 252 x 56.2 cm, Bahr-Mildenburg Estate, Österreichisches Theatermuseum, Vienna.

p. 63: Gustav Klimt, *Pallas Athene*, 1898, oil on canvas, 75 x 75 cm, Wien Museum, Vienna.

p. 64: Moritz Nähr, Klimt's studio, *c.* 1910, photograph.

p. 65: Gustav Klimt, *Reclining Half Nude Facing Right*, *c.* 1914, pencil, red and blue color pencil on paper, 37.1 x 56 cm, private collection.

p. 66: Mizzi Zimmermann, *c.* 1903, photograph.

p. 67: Emilie Flöge, *c.* 1910, Lumière autochrome plate by Friedrich Walker.

p. 68: Gustav Klimt, *Sunflower*, 1907, oil on canvas, 110 x 110 cm, private collection.

p. 69 top: Gustav Klimt, Emilie Flöge and Helene Flöge beside the Attersee, *c.* 1905, photograph.

p. 69 bottom: Group meal outdoors, Gustav Klimt on the right, standing, 1908, photograph.

p. 70: Gustav Klimt, *Allegory of Love*, 1895, oil on canvas, 60 x 44 cm, Wien Museum, Vienna.

p. 71: Gustav Klimt, *Emilie Flöge at Seventeen*, 1891, pastel on card, 67 x 41.5 cm, private collection.

p. 72: Gustav Klimt, *Water Snakes I*, *c.* 1904–1907, mixed media on parchment, 50 x 20 cm, Österreichische Galerie, Belvedere, Vienna.

p. 73: Gustav Klimt, *Danae*, *c.* 1907/08, oil on canvas, 77 x 83 cm, private collection.

p. 74: Gustav Klimt, *The Marsh*, 1900, oil on canvas, 80 x 80 cm, private collection.

p. 75: Gustav Klimt, *Island on the Attersee*, 1902, oil on canvas, 100 x 100 cm, private collection.

p. 76: Garden front of the Palais Stoclet, Brussels, *c.* 1910, photograph.

p. 77 top: The dining room of the Palais Stoclet, with Gustav Klimt's frieze on the walls, photograph.

p. 77 bottom: Gustav Klimt, sketch for the *Stoclet Frieze*, *c.* 1908, pencil, watercolor and opaque colors, gilt bronze, tracing paper. 22 x 75.3 cm, Österreichisches Museum für angewandte Kunst, Vienna.

p. 78: Gustav Klimt with painting smock and cat outside his studio, photograph.

p. 79 top: Postcard with a photograph of Schloss Kammer on Attersee, sent by Gustav to Anna Klimt, *c.* 1908, private collection.

p. 79 bottom: Gustav Klimt's blue painting smock, Wien Museum, Vienna.

p. 80: Gustav Klimt's death mask, Wien Museum, Vienna.

p. 81: Gustav Klimt, Self-caricature, *c.* 1902, blue pencil, 44.5 x 31 cm.

p. 82: Gustav Klimt, *Expectation* (detail), cartoon for *Stoclet Frieze*, *c.* 1905–1909, tempera, watercolor, chalk, gold, silver on wrapping paper, Österreichisches Museum für angewandte Kunst, Vienna.

p. 83: Gustav Klimt, *Fulfillment* (detail), part of the *Stoclet Frieze*, *c.* 1910, mosaic made of marble, glass and semi-precious stones (executed by Leopold Forstner), Palais Stoclet, Brussels.

p. 84: Gustav Klimt, *Portrait of Friederike Maria Beer*, 1916, oil on canvas, private collection.

p. 85: Gustav Klimt, *The Friends*, 1916/17, oil on canvas, 99 x 99 cm, destroyed by fire in Schloss Immendorf in 1945.

p. 87: Emilie Flöge and Gustav Klimt in the garden of the Villa Oleander in Kammerl, 1910, photograph.

p. 88: Alma Mahler (Schindler), 1909, photograph.

p. 89 top: Gustav Klimt, Emilie Flöge and her mother beside the Attersee, 1912, photograph.

If you want to know more

Cultural context:

Vergo, Peter, *Art in Vienna 1898-1918: Klimt, Kokoschka, Schiele and their Contemporaries*, London / Phaidon, 1975.

Schorske, Carl E., *Fin-de-siècle Vienna: Politics and Culture*, New York / Random House, 1980.

Natter, Tobias G. and Max Hollein (eds.), *The Naked Truth: Klimt, Schiele, Kokoschka and other Scandals*, Munich, New York / Prestel, 2005.

Life and works:

Comini, Alessandra, *Gustav Klimt*, London / Thames and Hudson, 1975.

Harris, Nathaniel, *The Life and Works of Gustav Klimt*, London / Parragon Book Service, 1994.

Nebehay, Christian M., *Gustav Klimt: From Drawing to Painting*, London / Thames and Hudson, 1994.

Partsch, Susanna, *Gustav Klimt: Painter of Women,* Munich, New York / Prestel, 1994.

Whitford, Frank, *Gustav Klimt*, New York / Crescent Books, 1994.

Fliedl, Gottfried, *Gustav Klimt, 1862–1918: The World in Female Form*, New York / Taschen, 1997.

Drawings:

Hofstätter, Hans H., *Gustav Klimt: Erotic Drawings*, New York / H.N. Abrams, 1980.

Sabarsky, Serge, *Gustav Klimt: Drawings*, Mount Kisco, N.Y. / Moyer Bell, 1985.

Rainer Metzger, Rainer, *Gustav Klimt: Drawings and Watercolors*, London, New York / Thames and Hudson, 2005.

Landscapes:

Dobai, Johannes, *Gustav Klimt: Landscapes*, London / Weidenfeld and Nicolson, 1988.

Stephan Koja (ed.), *Gustav Klimt: Landscapes*, Munich, London / Prestel, 2006.

Gustav and Emilie:

Fischer, Wolfgang G., with the assistance of Dorothea McEwan, *Gustav Klimt and Emilie Flöge: An Artist and his Muse*, London / Lund Humphries, 1992.

The Beethoven Frieze:

Koja, Stephan (ed.), *Gustav Klimt: The Beethoven Frieze*, Munich, New York / Prestel, 2006.

Imprint

The pictures in this book were graciously made available by
the museums and collections mentioned, or have been taken
from the Publisher's archive with exception of:
© Getty Images: Page 123
Artothek, Weilheim: Pages 24, 32
© Board of Trustees, National Gallery of Art, Washington D.C.:
Page 108
© Frank Trapper / Corbis: Page 117
© Ann Johansson / Corbis: Page 121
Wien Museum : Pages 6, 9, 13, 23, 34, 58, 63, 70, 79 below, 80,
97, 101
National Gallery of Canada, Ottawa: Page 98
Österreichische Galerie Belvedere, Wien: Pages 12, 25, 26, 27,
30, 31, 40, 41, 42, 43, 61, 72, 104, 115
© The Metropolitan Museum of Art, New York: Page 59
Wadsworth Atheneum, Hartford, Connecticut: Page 55 above
www.antiquedress.com, © Deborah Burke: Page 116
Wien Museum: Pages 13, 23, 34, 63
www.klimtderfilm.at, © Bernhard Berger: Pages 111, 118, 119
AP Photo / Gino Domenico: Page 112
AP Photo / Kathy Willens: Page 120
Florian Monheim: Page 114

The Library of Congress Control Number: 9783791337791
British Library Cataloguing-in-Publication Data: a catalogue
record for this book is available from the British Library.The
Deutsche Bibliothek holds a record of this publication in the
Deutsche Nationalbibliografie; detailed bibliographical data
can be found under: http://dnb.ddb.de

© Prestel Verlag, Munich · Berlin · London · New York 2007

Prestel Verlag
Königinstrasse 9
80539 Munich
Tel. +49 (89) 38 17 09-0
Fax +49 (89) 38 17 09-35

Prestel Publishing Ltd.
4, Bloomsbury Place
London WC1A 2QA
Tel. +44 (0) 20 7323-5004
Fax +44 (0) 20 7636-8004

Prestel Publishing
900 Broadway. Suite 603
New York, N.Y. 10003
Tel. +1 (212) 995-2720
Fax +1 (212) 995-2733

www.prestel.com

Editorial direction by Claudia Stäuble and Reegan Finger
Translated from the German by Paul Aston
Copy-edited by Chris Murray
Series editorial and design concept by Sybille Engels, engels
zahm + partner
Cover, layout, and production by Wolfram Söll
Lithography by Reproline Genceller
Printed and bound by Druckerei Uhl GmbH & Co.KG,
Radolfzell

Printed in Germany on acid-free paper

ISBN 978-3-7913-3779-1